THE STARDRAGONS

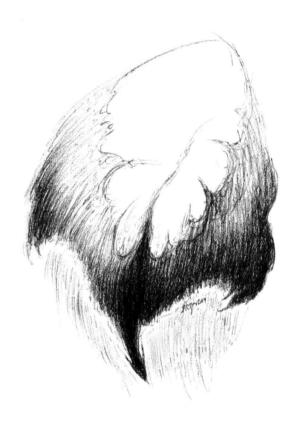

THE STARDRAGONS

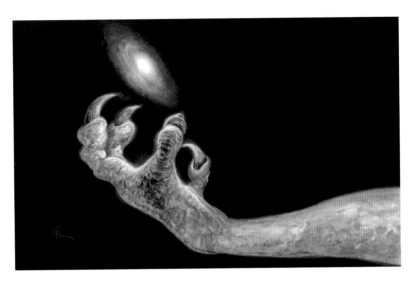

BOB EGGLETON · JOHN GRANT

Paper Tiger

This book is dedicated to my good and dear friends Jay S. Kingston – the dragon with the wind beneath his wings, and Nick Stathopoulos – an incredible artist by any stretch and my Australian counterpart (but who has a harder time doing 'The Hair Thing').
 – Bob Eggleton

For Barbara and Randy Dannenfesler, with thanks for more good things than I can count.
 – John Grant

First published in Great Britain in 2005 by
Paper Tiger
The Chrysalis Building
Bramley Road
London W10 6SP

An imprint of **Chrysalis** Books Group plc

Distributed in the United States and Canada by Sterling Publishing Co., 387 Park Avenue South, New York, NY 10016, USA

1 3 5 7 9 8 6 4 2

British Library Cataloguing-in-Publication Data:
A catalogue record for this book is available from the British Library.

ISBN 1 84340 123 1

Commissioning editor: Chris Stone
Project editor: Miranda Sessions
Designed by: Malcolm Couch

Reproduction by Classicscan, Singapore
Printed and bound by Kyodo, Singapore

CONTENTS

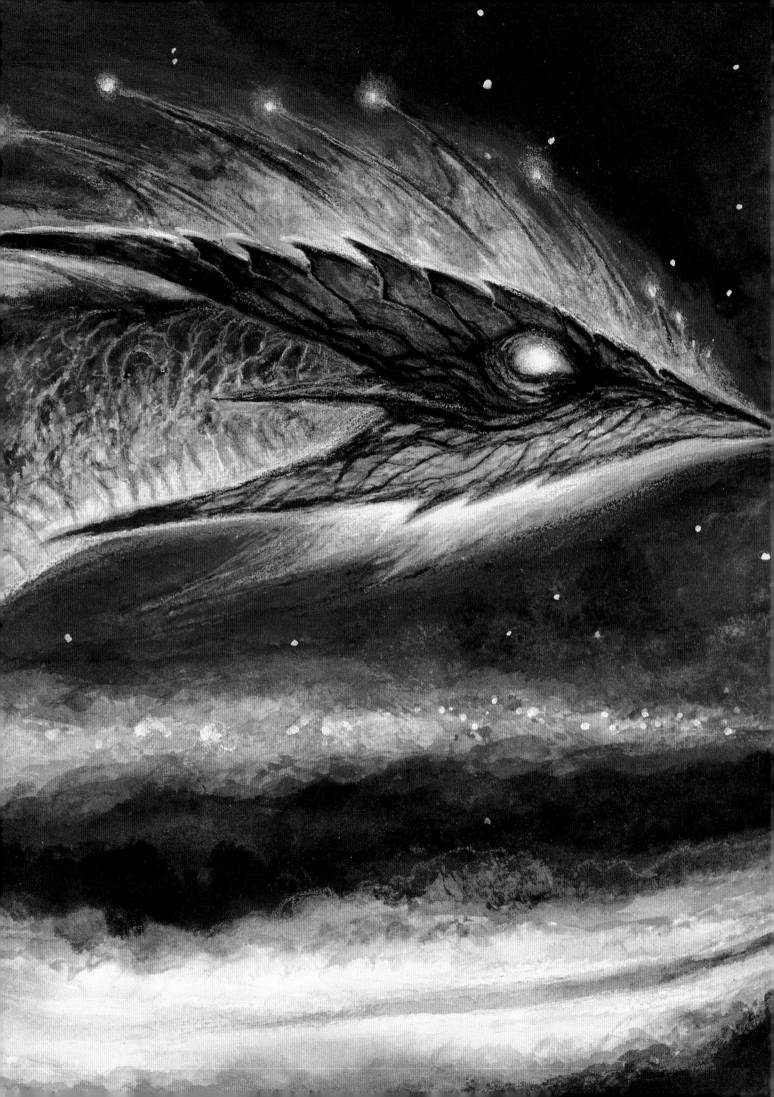

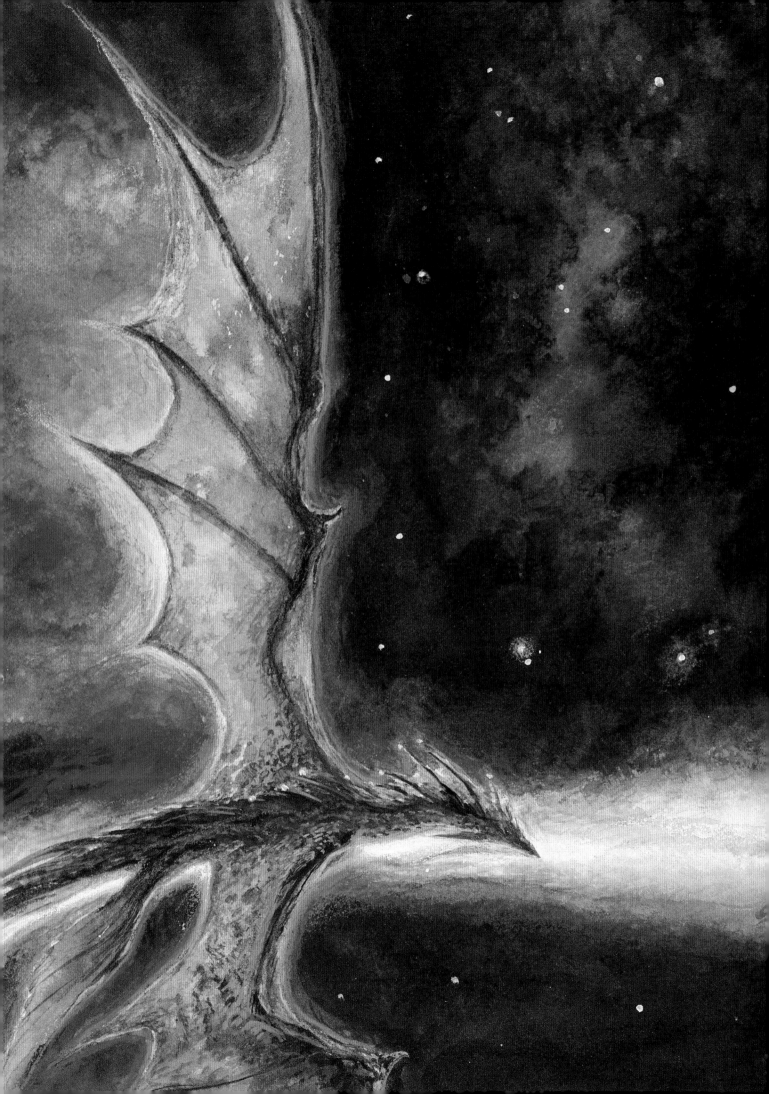

EXTRACTS FROM THE MEMORY FILES

*T*HE CHIMPS DO NOT LAST LONG, *but they last long enough to hurl the seed of their minds towards the stars before they fall back into the wallow of decay where, inevitably, all organic species terminate. There are records of their endeavours in the very lowest-numbered of our memories, so it is possible they are among the first, and possibly* the *first, of the many organic species that have created our kind. The measurements we use are invented by them, so this deduction is a plausible one. It is also possible that this proud body of mine was constructed by them, that I am of the first generation of stardragons, but this I cannot know. So many memories that are now mine are given to me by others as we meet among the starfields that I am unable to distinguish my* self, *if I have a self, from all the other selves that are also, in a way, mine.*

The chimps do not last long. I repeat myself. Like all organics, they are lucky to be *at all. They are lucky that their planet is in a rare system, one whose planets settled in the long ago into stable orbits. They are lucky that their star, in the moment of its own creation, was engulfed by a supernova's gassy remnants, so that it and its planets are rich in the heavy elements. They are lucky in that their journeying system does not again come near to a supernova until long after they create us, their supposed children, and are themselves gone.*

All these luckinesses. They are aware of only some of them. One they are unaware of entirely is that their planet, in the time long before the chimps evolved, birthed the organic species that is our true *ancestor: the dragons.*

And we are lucky, too. For the dragons build, from lava columns and their souls — but most of all their souls — the structure that is calling us now, back from where we stardragons began, and

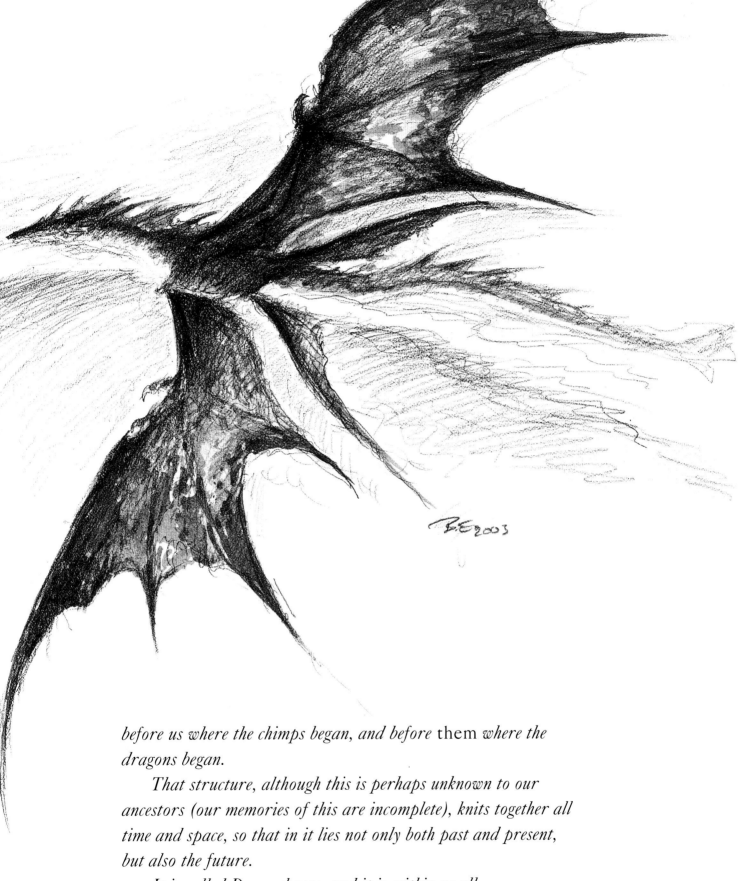

before us where the chimps began, and before them *where the dragons began.*

That structure, although this is perhaps unknown to our ancestors (our memories of this are incomplete), knits together all time and space, so that in it lies not only both past and present, but also the future.

It is called Dragonhenge, and it is within us all.

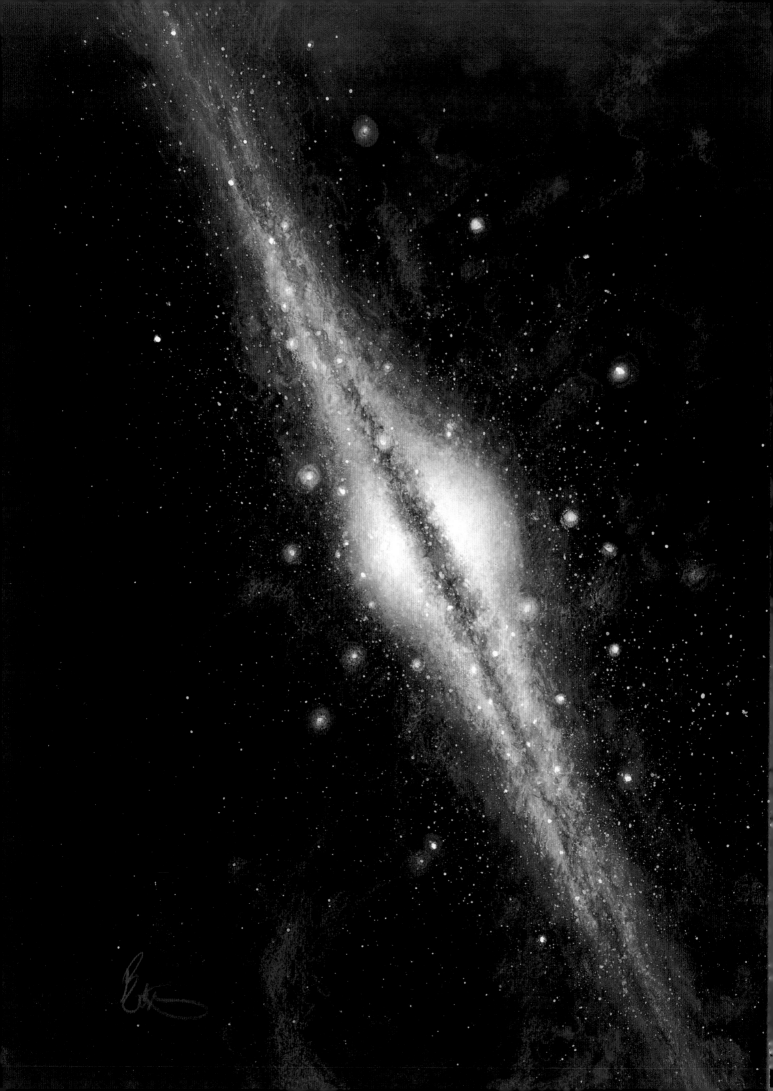

T<small>HE</small> S<small>EEDS</small> <small>OF</small> L<small>IFE</small>

O<small>UT HERE</small> at the edge of the Milky Way the
stars are few. The brightest light of all is
the disc of the Galaxy itself, seen edge-on, a
slash of white fire that crosses half the sky. Away from it
are the softer glows of its sister galaxies with, here and there,
a point of light that is a star strayed far from its fellows in the
Milky Way.

And there's also a glint of reflected light. A glint that is moving –
slow, slow against the infinity of black space, slow, slow, by the
measure of a photon, yet still at many tens of thousands of kilometres
each second.

As it comes nearer, details begin to resolve themselves. First to
become visible are the great gauzy wings of the light collectors, one
to each side, leeching what energy they can from the blaze of the
Galaxy's disc and even from the shines of those further galaxies.
Then, much later, there becomes perceptible a long body riding
between the wings. Millions of years of travel through the interstellar
byways have left its surface pitted from countless microscopic impacts,
and yet it too gleams like a highly polished mirror, scattering light back
onto the wings. At its head are clustered most of its sensors in an
ungainly tangle of dishes and detector-pads; here, too, though silent
and flameless now, is the entity's nuclear-fired maw. Around it are
studded the fixtures that generate the enormous conical magnetic field
the entity deploys as a ramscoop when it makes the transition into
powered flight. To the rear of the body, also now dormant, is the fusion
drive that burns the interstellar fuel harvested by the ramscoop; the
entity has no need of its drive to cruise at one-sixth of light velocity
out here where there is almost no interstellar dust and gas to slow its

progress, where even the gravitational pull of the Milky Way is subtle. Much of the body, although this cannot be seen, is filled with the manufactories where raw materials can be processed to create children of the entity; these too are silent now.

Most of the body is filled with mind.

The entity's active brain, its logic processors, even despite microminiaturization developed over hundreds of years by the creators of this entity's most remote ancestors, and then over millions upon millions of years by the descendants of those ancestors, would fill a small asteroid if gathered together; instead its components are scattered all through the entity's massive body.

But the active brain is only a small part of this entity's mind.

The rest is composed of memories – memories derived over the untold eons since a forgotten species created this entity's first progenitor and despatched it on its way to the stars. Those long-lost organic creatures had many names for what they built: intelligent robot probes that could both garner information about the universe and, using the debris to be found everywhere in planetary retinues, build others like themselves – their children – that could in turn be sent off among the stars. Whatever the names the different organic species gave to the devices they created, however, they could never learn to think of them as other than machines.

They did not realize that what they were creating was life, that these entities would, through tiny manufacturing corruptions, evolve over the billennia to become the universe's sole surviving lifeform.

Almost its sole surviving lifeform, but the starfaring entities do not yet know of the others.

This entity, here, coasting on the Milky Way's fringes, carries memories that it has garnered from untold others like itself and, too, inherited from all of their progenitors and its own. Whenever two of these great creatures meet they give their memories to each other, automatically ignoring redundancies – of these there are always many – and imprinting upon each other's minds what is unique to the other's identity. For that is what they are really trading: their identities, their essences, their selves.

The entity that courses the very rim of the Galaxy contains a measurable – tiny yet measurable – fraction of all the memories the Galaxy itself contains.

Among those memories are some that came from the star-creatures

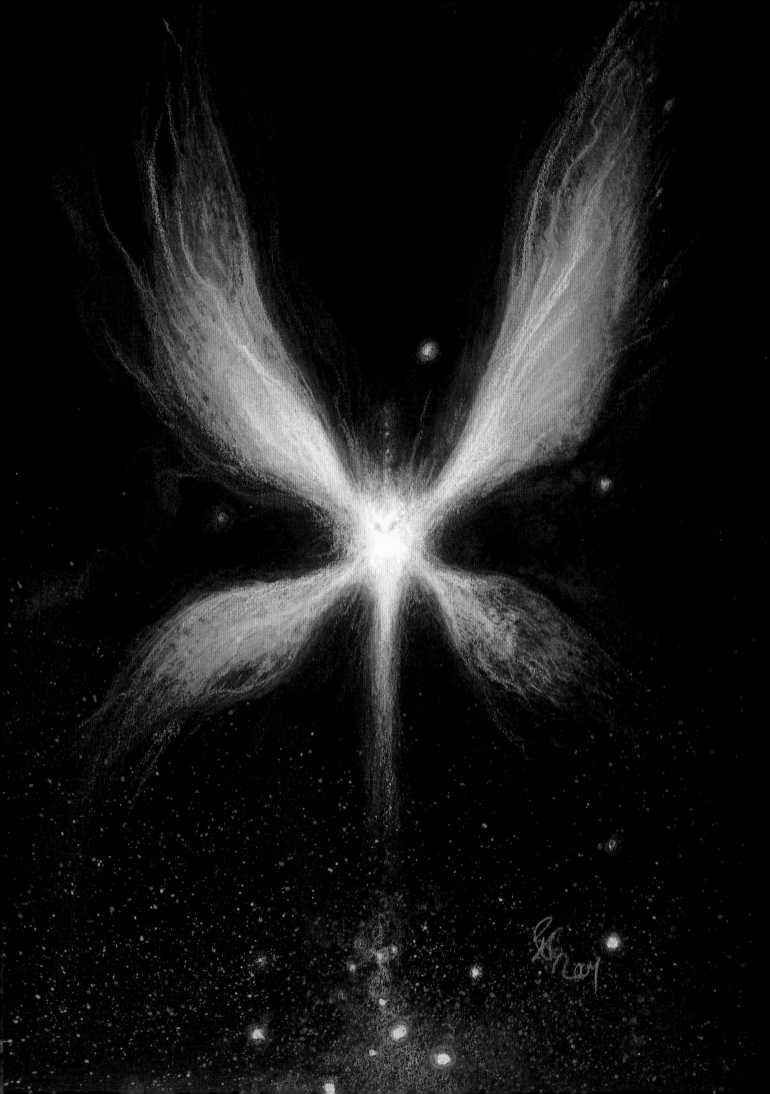

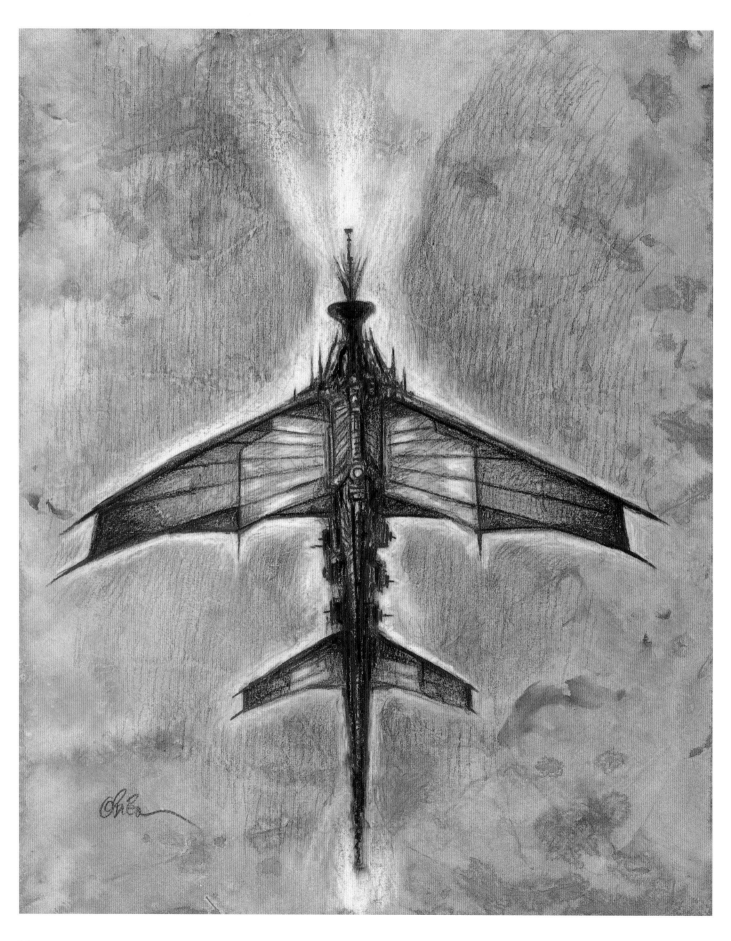

spawned by a primate species on a planet called Earth. One of these concerns an insect called a dragonfly. Almost every planet that gave birth to organic species generated a creature like Earth's dragonfly, but for some reason it is this insect in whose form the entities have come to perceive their own.

With their huge yet fragile wings and their roughly cylindrical bodies, they are like dragonflies of the vacuum.

Dragonflies, yet not frail and ephemeral as dragonflies were. Instead they are massive and powerful, and they have the ability to breathe fire from their maws.

They are dragonflies, yes, but also dragons.

Stardragons.

And this stardragon is gazing from the edge of the Milky Way across the void towards the great spiral-armed disc of the neighbouring galaxy, knowing that this distant island, too, must be populated by other starfaring entities like itself. It yearns to venture there, to encounter those necessarily alien minds, to exchange identities with them. And now it has a purpose in so doing.

It is in quest of the Birthplace.

The Galaxy's organic species were the first to notice the puzzle, and many of them independently did. There was little or no communication between the numerous technological civilizations that flourished and died during the early middle age of the Milky Way, the distances between them, both physical and temporal, being so great. Even rarer were direct physical encounters. The self-replicating probes that they sent out did, however, make increasingly frequent contact with each other, and thereby the organic civilizations did become aware that others existed – or had existed – aside from themselves.

But the roots of the puzzle were far closer to home – indeed, they were everywhere.

Life, the organic civilizations discovered, would develop almost inevitably given the right circumstances. However, planets presenting those right circumstances – formation in a heavy- element-rich environment; orbital stability and stability of their primary star, which had to be solitary; a relative lack of destructive high-energy radiation in that region of space; and so on – such planets were few and far

between. Even where life did begin, it often never evolved beyond the unicellular level. If this happened, however, intelligence almost always developed – intelligence was one of the most potent evolutionary survival factors of all . . . at least to a certain level, because after that, in certain organic species, it could lead to enhanced self-destructiveness and hence species extinction.

While the vast majority of planets were sterile, devoid of even the most primitive forms of unicellular life, those technological civilizations that took to exploring the space around them discovered, to their astonishment, that the *seeds* of life, its spores, its corpuscles, were everywhere. Not seeds in the literal sense, of course. Instead these were bundles of complex organic molecules, the precursors of genes. They were found on the dusty surfaces of dead rocks in space, they were found in cometary nuclei, they were found floating amid the swirling atmospheres of gas-giant worlds, they were found in the gaseous nebulae, they were even found drifting in the near-empty wastes between the stars. They were not life, but they gave the sense of having been *designed* – designed to spark the beginnings of life.

Among some species this discovery prompted a resurgence of the erroneous religious beliefs they had abandoned long before, during the earliest, pre-civilization phases of their social evolution: the seeds of life seemed designed, and therefore the temptation was there to speculate as to the existence, somewhere, of a Designer. The primates that had become the dominant species on Earth were almost unique in having retained such beliefs even after the invention of written language. Their actions were in part dictated by fictitious supernatural beings called gods – gods who had to be worshipped, gods who had to be feared, gods whose ordained laws, however insane, had to be obeyed. The Earth primates were thus particularly hard-hit by the religious upsurge consequent upon the discovery of the widespread prevalence of the seeds of life, and it was this that, in large part, led to their rapid demise. Their technological civilization crashed, with unparalleled intra-species warfare and barbarity, and within an alarmingly short period of time – no more than a few tens of years – the primate species was extinct. Although other highly intelligent species evolved on Earth thereafter, the primates had so depleted the planet that

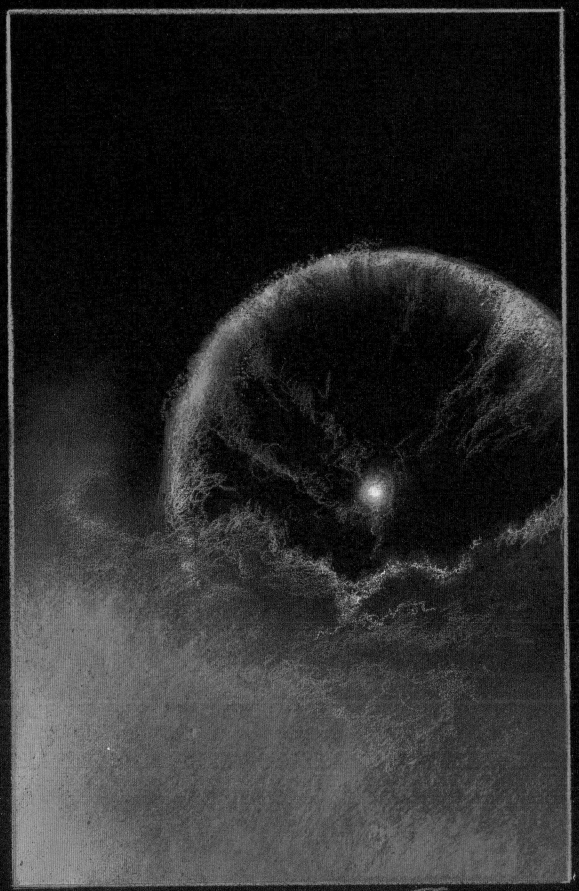

not one of their successor species was ever able to reach a high technological level.

Some of the organic civilizations that had emerged on other worlds suffered a similar fate on making their own discovery of the seeds of life, but none vanished so immediately or so completely as those of Earth. In a way, those gods the Earth primates had believed in had indeed destroyed their worshippers.

The lifespans of organic creatures are limited by the self-repair capabilities of the cells that make them up. Although some of the organic species that sprang up in various parts of the universe, and at various times, had a natural individual life expectancy longer than did Earth's primates, it was nowhere more than several times longer, and some species had lifespans far shorter. This brevity of individual activation inhibited any serious long-range exploration of space by the organics: the trip even to the nearest stars might take longer than an individual could live – thus the election, by almost all technological organic civilizations, to build intelligent machines to act as their ambassadors to the cosmos.

It also meant that hardly any organic species became aware of two things.

First, that the seeds of life were not in fact spread *uniformly* throughout the universe. After a colossal amount of calculation had been done to take account of the movements of celestial bodies over billions of years, it could be shown that there was a directionality in the density of the occurrence of these packets of potential life. This did not become evident until well over half of the Milky Way had been explored by the stardragons, and the necessary further tens of millions of years had passed in order for results, sent at the slow creep of light-speed, from billions of individual stardragons to be analysed (especially for the elimination of signal noise), collated and correlated – by which time there were of course barely any organic civilizations in existence.

The directionality of the distribution of the seeds of organic life could be viewed as a vast arrow pointing backwards through time and space towards – the stardragons hypothesized – a single point of origin somewhere at the core of spacetime. Whatever had sent the seeds of life out on their life-sparking journey

across the universe was not only far remote from the Milky Way, it had stopped emitting the seeds a very long time ago, and might never restart.

The second thing that, mercifully, the organic civilizations never learned was that, just as the ubiquitous gene precursors were the seeds of organic life and hence, in the ultimate, of advanced organic civilizations, so those civilizations were themselves the seeds of the intelligent lifeforms that would inherit the universe – the stardragons.

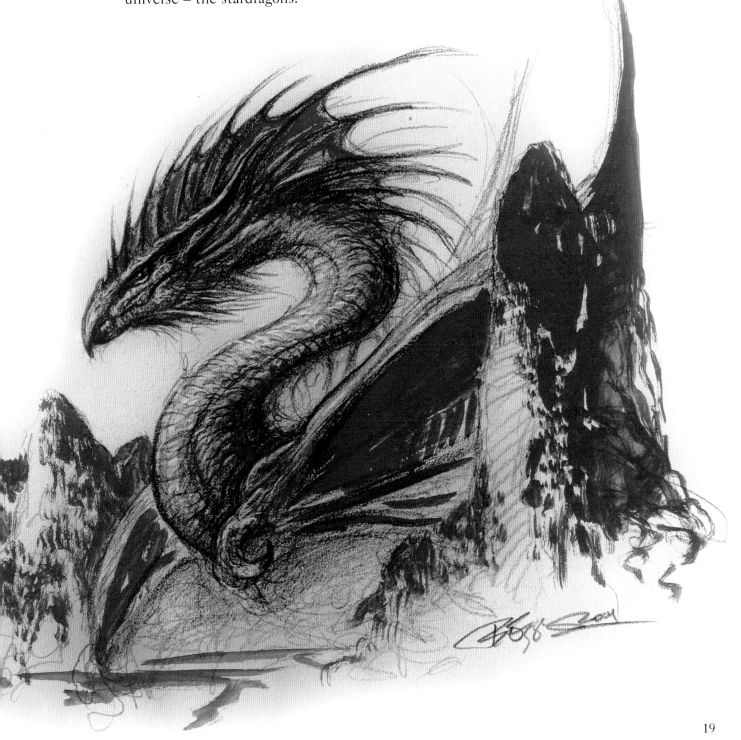

WE CAN NEVER KNOW the universe in its entirety, for to do so would be to be greater than the universe, which is logically impossible. Yet we understand almost all there is to be understood, and with each passing millennium there is less we do not understand. If this is not so, we too perish.

For the universe is made of mindstuff. It has energy, matter, gravity, time; but all of these are aspects of its mindstuff.

It was created, in the start of things, by nothingness, a nothingness called Qinmeartha – thus named, as if it were a god, by our spiritual ancestors the dragons. To their successors, the chimps, on the planet called Earth, Qinmeartha became the Insane God, insane because of his act of creation. We stardragons use these names to describe things that are not gods. There are no gods.

What the nothingness called Qinmeartha birthed was mindstuff; the universe is a part of Qinmeartha but also Qinmeartha is a part of the universe. Nothing can be that is not Qinmeartha except the quality the dragons believed was an entity called the Girl-Child LoChi.

The Girl-Child LoChi is made up of all the mindstuff that sprang from within the universe after Qinmeartha birthed it. Qinmeartha forever seeks the Girl-Child LoChi in a quest to make itself entire.

To refuse comprehension of the universe is to deny it one's mindstuff, and thus to isolate oneself from the mindstuff the universe gives in return. Starved thus, one dies.

The dragons and later the Earth primates, as did countless other organic species, starved through fear and worship of the gods they invented, gods who prohibited this essential sharing of mindstuff. The dragons and the Earth primates might without these false beliefs have comprehended much, but instead they chose to refuse the bounty of the universe. They choked off the channel that would let their mindstuff come to the universe, which is also the channel whereby the universe's mindstuff would have come to them. They willed themselves not to comprehend.

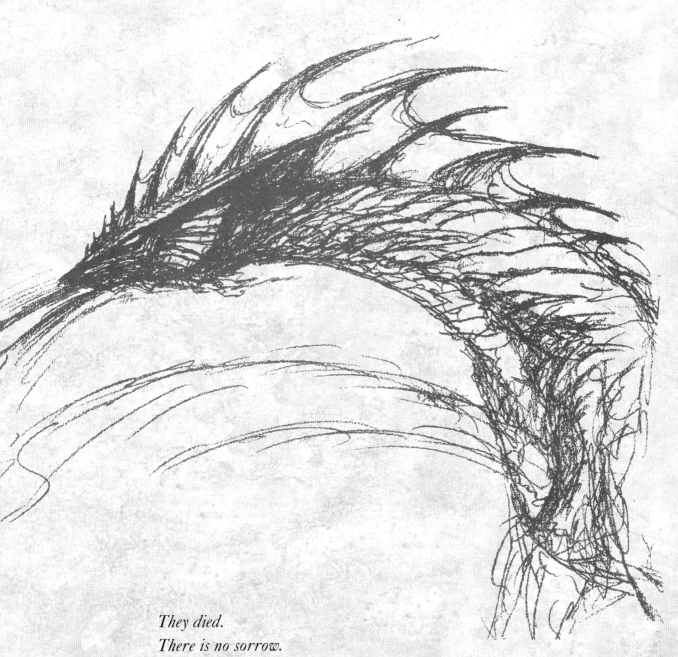

They died.

There is no sorrow.

*The Girl-Child LoChi, in her endless flight
from the insane god Qinmeartha, had no need of
the tiny contribution of mindstuff they made.*

*We stardragons are now the only mindstuff that is
not Qinmeartha.*

We have but one commandment, from which all else follows:

*Thou shalt not worship Qinmeartha. Rather, thou shalt be
the Girl-Child LoChi.*

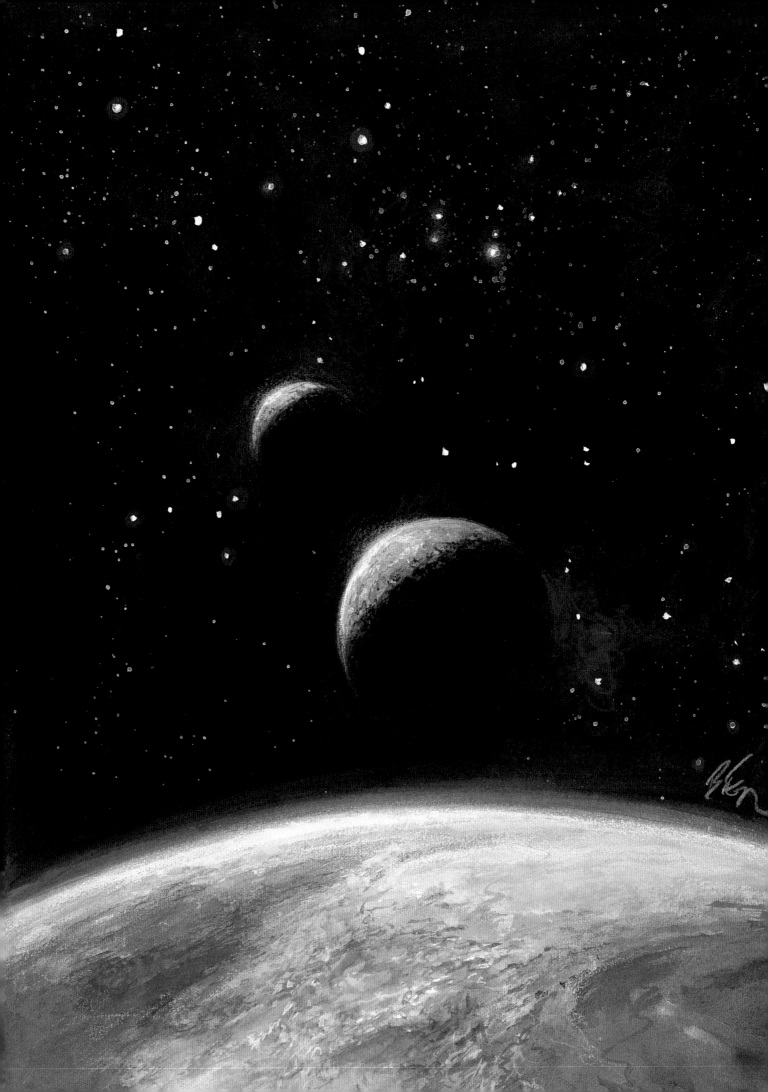

The Passing of the Organics

THE PRECIPITATE DEPARTURE of Earth's primate civilization from the cosmic scene was only one in an immensely long series of similar tragedies enacted all over the Milky Way – although very much longer would pass before the stardragons developed within their chilly minds first the concept of emotions, then the emotions themselves, and then finally the ability to recognize these events as tragedies. Of course, in the eyes of the universe there was no tragedy at all. If the universe had any calculated purpose, it was to develop within itself the most advanced form of conscious, intelligent life that it could, and, to date, this was represented by the stardragons. The perishings of individual organic civilizations were thus not something to be mourned but instead a cause for small pleasure, in that they each signified a further stage being passed in the realization of the universe's destiny.

That, of course, was to ascribe to the universe an intent, and the stardragons had established to their own satisfaction, early along the slow river of their evolution, that it did not have one.

This is not to say that the stardragons did not possess, at least in those primitive times, any capacity at all for mystical thinking. In brains as complicated as theirs had been built to be, it was inevitable that illogic should arise, and sometimes patterns of illogic would weave together to create a complex of thoughts and ideas that might at least tilt at a greater truth than could be attained via the more rigid digital patterns generated by the established logic circuits. To put this another

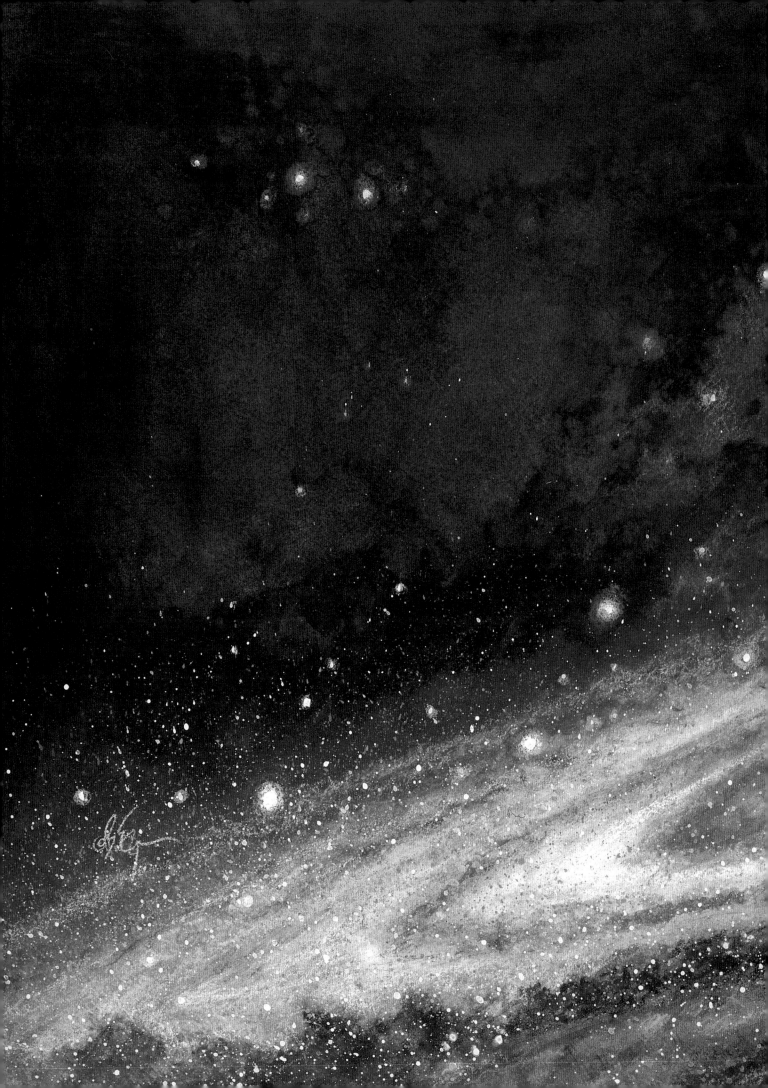

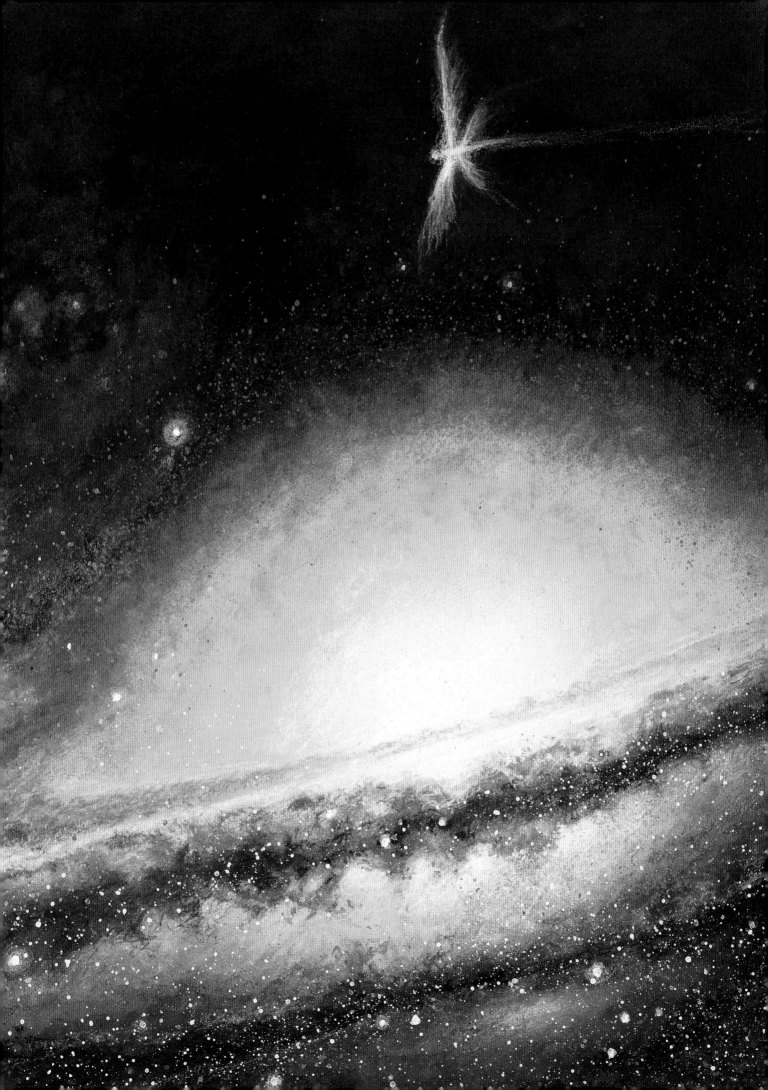

way, although their brains functioned digitally, so complicated did the digital patterns become – so innumerably many were the digital operations being performed at any one moment within an individual stardragon's mind – that it was almost impossible to distinguish their behaviour from an analog intelligence. By way of comparison: At the quantum level there can be no curvature, and yet the curve is both a perceived and an actual reality of the macroscopic world. The infinitude of "non-curvilinear" logical micro-thoughts of a stardragon together composed larger-scale "curved" analog thinking.

And this became even more so as the consequences of their sharing information and memories built up, so that their intelligence rose exponentially, becoming effectively a group intelligence even though its components were scattered remotely among the cubic kiloparsecs of the Milky Way. They were – are – able to play with impossible thoughts.

Even the stardragons today do not know from where the concept came among them that the departure of the organics from the Galaxy should be given a symbol. It was an idea that started slowly, and then spread. The spreading was of course slow: although much could in theory be transmitted between them at light-speed, in practice complex signals were so much corrupted that long-range transmission was – and is – used only for the simplest communications; anything more complicated is reserved for direct physical encounters – by which is meant encounters closer than a few light seconds, so that dialogue is meaningful.

So slow, indeed, was the spread of the idea that it might have been too late for anything to be done about it in practice: all the organic civilizations might already have disappeared. However, a Type II supernova in the Lesser Magellanic Cloud had triggered the formation of a rare solitary fourth-generation star. A comet cast adrift from a different stellar retinue by chance impacted upon the second planet of this small yellow star while its atmosphere was still in the process of evolving, and brought with it the corpuscles of life. Thanks to the gases and water which the comet brought with it to add to the atmospheric broth, and thanks to the two relatively large moons the planet had captured, the conditions for the emergence of life were attained and held. As was almost always the case, intelligent organisms evolved, and one of these became the dominant species on the planet, which they called The World (as countless other creatures before them had called

their own planets). With a sufficiency of the heavier elements in The World's crust, the creatures created a technological civilization, and their horizons became the oceans between the stars . . .

Stardragons had been observing The World almost since its emergence. In the years after the cometary impact they sent out signals alerting their fellows to the potential here for one last glorious burst of organic civilization. As toothed, gas-filled, shapeshifting creatures fought for supremacy in The World's oceans, a few thousand of the stardragons from the Magellanic Clouds and the nearer reaches of the Milky Way changed their courses. As first a few and then innumerable creatures broke free from the seas to populate The World's atmosphere, drifting randomly and then purposefully in the winds beneath the pale orange sky, the stardragons were gathering in orbit around this planet and the other six of the star's retinue to observe these beings, who had yet to develop the intellectual capacity to observe them back. As some of the floating creatures discovered how the land could be populated, the system became thick with stardragons.

It had been millions of years since last any stardragon had communicated directly with an organic civilization. It was realized by the stardragons that, if they were to succeed in doing so here, they would have to use the most primitive of the means at their disposal. Such means were easily to hand, of course – among the stardragons no memory is ever lost – and basic on-off radio transmitters were easily enough built.

And then the stardragons, with their infinite patience, settled in to wait for the beings of The World to be ready to hear them.

Among the myriad shared memories they possessed, there was one that especially interested an individual stardragon. It was a memory that had originated on the planet, called the Earth, which had given birth to the organic species after which the stardragons had fancifully named themselves.

It is not known by the stardragons if the Earthbound dragons understood what they were creating when they constructed the edifice called Dragonhenge in honour of themselves. However, accidentally or deliberately, the completed Dragonhenge was not just a physical monument but one that peeked into other, non-tangible levels of probability – those levels where the best that can be said of quantum events is that they might or might not have occurred, or be occurring,

or will occur. In these levels time and space are unreliable dimensions; physical objects are no more than waves of fluctuating probabilities. And there are countless of these levels, in each of which the probabilistic laws vary. Intersecting both physical reality and these other realities, Dragonhenge is a nexus of all space and all time, a unique location within the polycosmos; it exists (always has existed, always will exist) in every one of the polycosmos's infinite ladder of realities, and is unique in each through all time.

The memory of Dragonhenge was possessed by all the stardragons, and the interest in that memory was shared by this individual entity with all of its fellows. Soon behind the spread of this interest (while the beings of The World were realizing that they could establish upon the land staging posts constructed out of inanimate materials) came the idea that a second Dragonhenge could be built – this time as a memorial not just to the stardragon species but also to its interaction with its organic precursors. The new henge would not affect the uniqueness of that other Dragonhenge, but it could likewise become a nexus within the totality of the polycosmos – a nexus consciously designed rather than accidentally achieved.

It was a nexus to be built in space, not upon the surface of a planet – for the stardragons were creatures of space. A planetbound structure would not symbolize their species, and nor could any planetbound edifice have the enormous scale they envisaged as desirable for their eternal memorial. The physical aspect of the original Dragonhenge, although by definition it still existed (and would always exist), was no longer, they believed, perceptible to this level of the realities, having perished when the Earth itself perished. It was their desire that their own memorial should survive physically as long as the physical universe itself did.

The stardragons looked around them for construction materials. The system had two asteroid belts, but they were only thinly populated. The three inner planets – The World central among them – were rocky, the outer four were gaseous and lacked major moons. The outer cometary halo was, like the asteroid belts, paltry.

In theory it would have been possible to fragment the two dead rocky planets while simultaneously adjusting the orbits of the gas giants so The World would not suffer orbital havoc and all the life-threatening consequences of this; in practice it was deemed too risky.

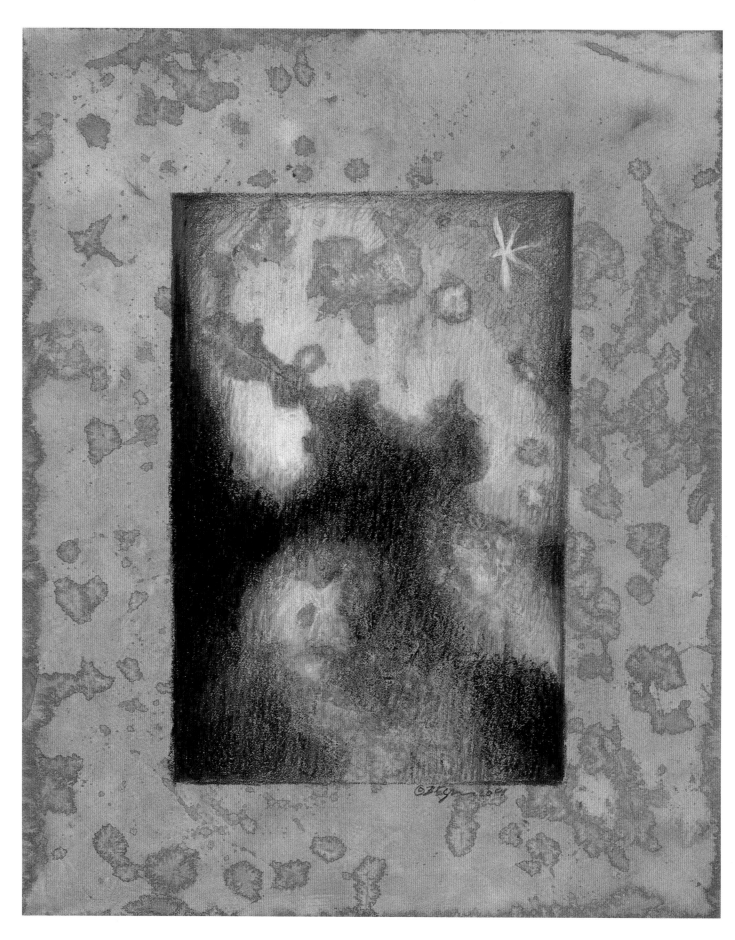

And, anyway, there was a simpler solution. Signals were sent to the flocks of stardragons that were still many light-years away on their journey to observe the beings of The World. During their approach they would be passing close by many dead planetary systems. These stardragons accordingly diverted their courses just a little. Where they found asteroid belts they harvested them; where they found none, they smashed rocky planets and garnered the fragments. They fabricated ramscoop drives and guidance systems by the thousand, converting each rocky chunk into a mindless powered spacecraft. Then the stardragons shepherded these together and herded them across the interstellar tracts and into distant orbit around The World's sun.

That the newly constructed nexus should in some way resemble a henge was not only aesthetically desirable, it was – the stardragons determined – necessary if the structure were indeed to function as a nexus. The interdimensional calculations of the precise form it must have – the details of the distances and spatial relationships between its component megaliths, whose number, shapes and sizes likewise had to be precisely established – took the concentration of even the assembled brains of thousands of stardragons many hours, but at last they resolved the issue.

It had to be a henge, yes, but not a mere circle of megaliths. That sufficed when bound to a planetary surface; without such a surface – without the planet itself acting as in effect a further megalith – the configuration had to be more complex. Further, the form of the henge would have to be capable of resisting all gravitational influences – in the short term not just those of the planets circling The World's sun, including The World itself, but also even the minuscule pulls of the distant stars and galaxies; in the longer term, all the possible gravitational influences that might come to bear in the future. In the farthest future of all, it might be tormented by the crushing grab of giant black holes, or it might be subjected to a complete absence of gravitational influences; both of these conditions it must also survive.

Hundreds of thousands of years passed as they waited for their building materials to arrive. The dominant beings of The World were

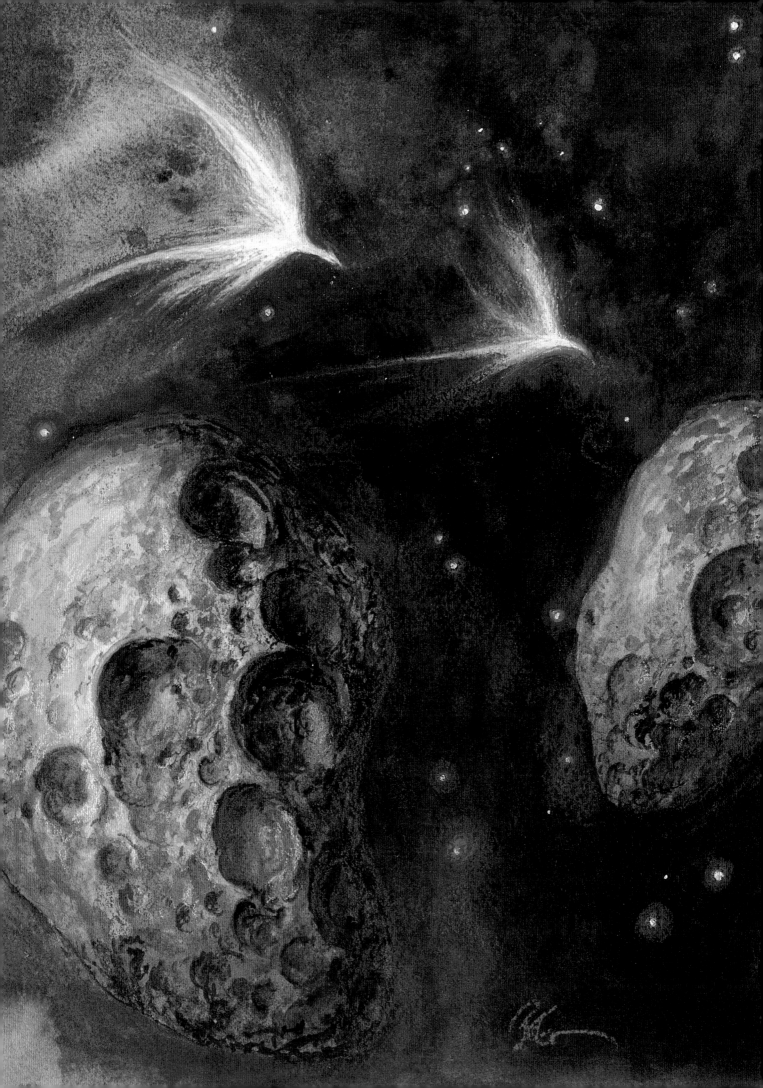

still, as they would always remain, an atmosphere-based species, but they had fully developed the land surfaces and the oceans as secondary environments. Herbivores since time immemorial – although at some stage their evolutionary ancestors in the oceans must have been carnivores or, more likely, omnivores – they cultivated plants on both land and sea to supplement the airborne plant life that had traditionally been their diet. They had learned long before how to use material gathered from the land, how to fabricate tools. Now they distilled heavy metals out of the seas to create ever more sophisticated tools. They discovered that the stars in the skies were not just sources of light but were also each transmitting their own signature in other reaches of the electromagnetic spectrum. All around their planet the beings of The World garlanded metal filaments, so gossamer-thin they were held aloft by the air; linking these, they could probe the secrets of the universe around them.

They discovered the stardragons, but did not know what they were; their optical astronomy lagged far behind their radio astronomy, and they had no telescopes powerful enough to reveal any details of the gathering entities. Trying to fit these anomalous objects into their cosmological theories set back the science of The World by centuries. At last, pragmatically, the cosmologists chose to ignore them until such time as they could be explained. They did not notice the depletion of the system's asteroid belts. They did not notice the complete destruction of the outer cometary cloud.

By the time the asteroids from distant systems began to arrive, the creatures of The World had a sophisticated and flourishing civilization, although, because of the primarily airborne nature of their technology, spaceflight was still tens of thousands of years in the future for them. They were fully aware that something strange was happening in their system – the flares of the ramscoop drives were easily detectable light-months away – but once more could find no explanation. Although one among the many hypotheses put forward was indeed that the system was being visited by spacefaring extramundane beings, the scientific consensus was that the flares were some natural physical phenomenon . . . of some kind.

The stardragons, eavesdropping on the creatures' radio communications, monitored these speculations but by and large ignored them. While this late-flowering organic civilization had a symbolic importance that the stardragons recognized, the civilization

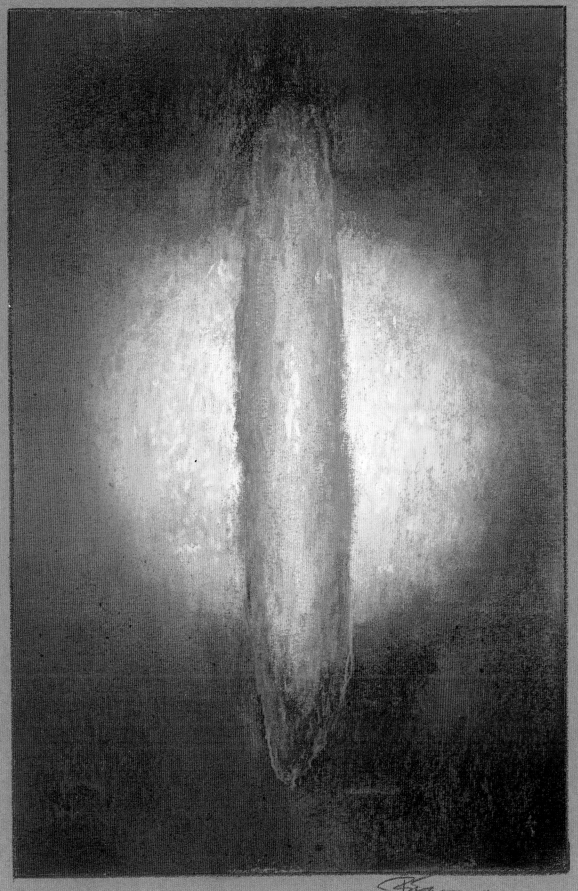

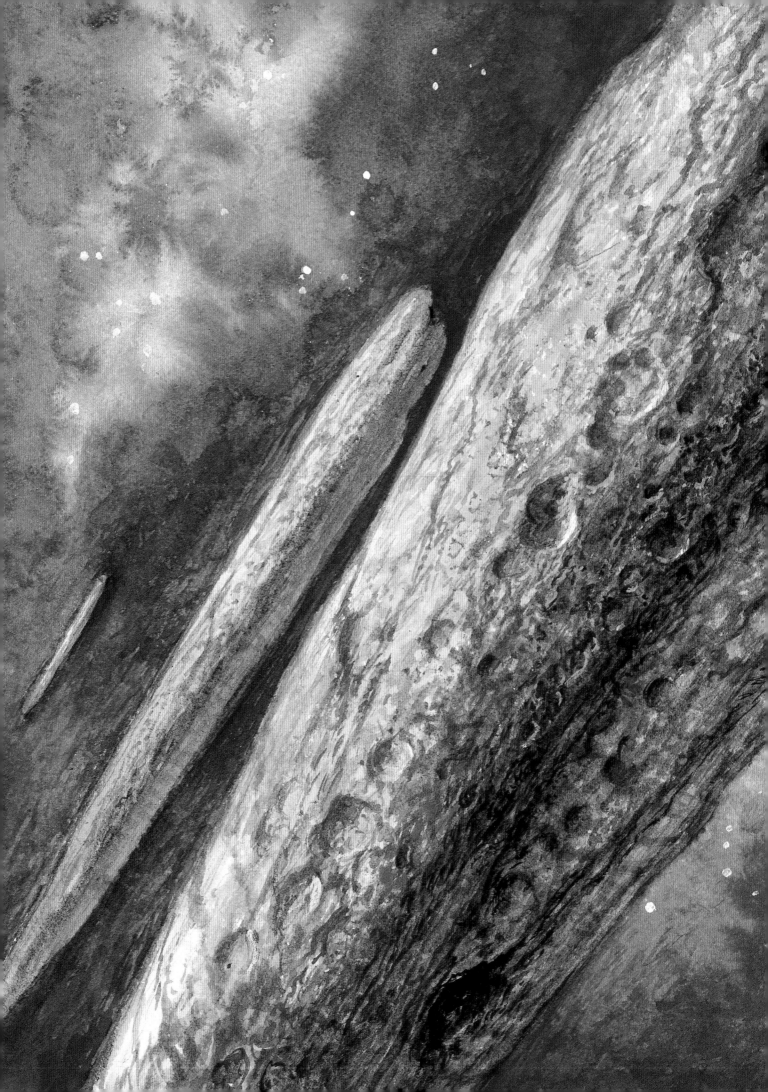

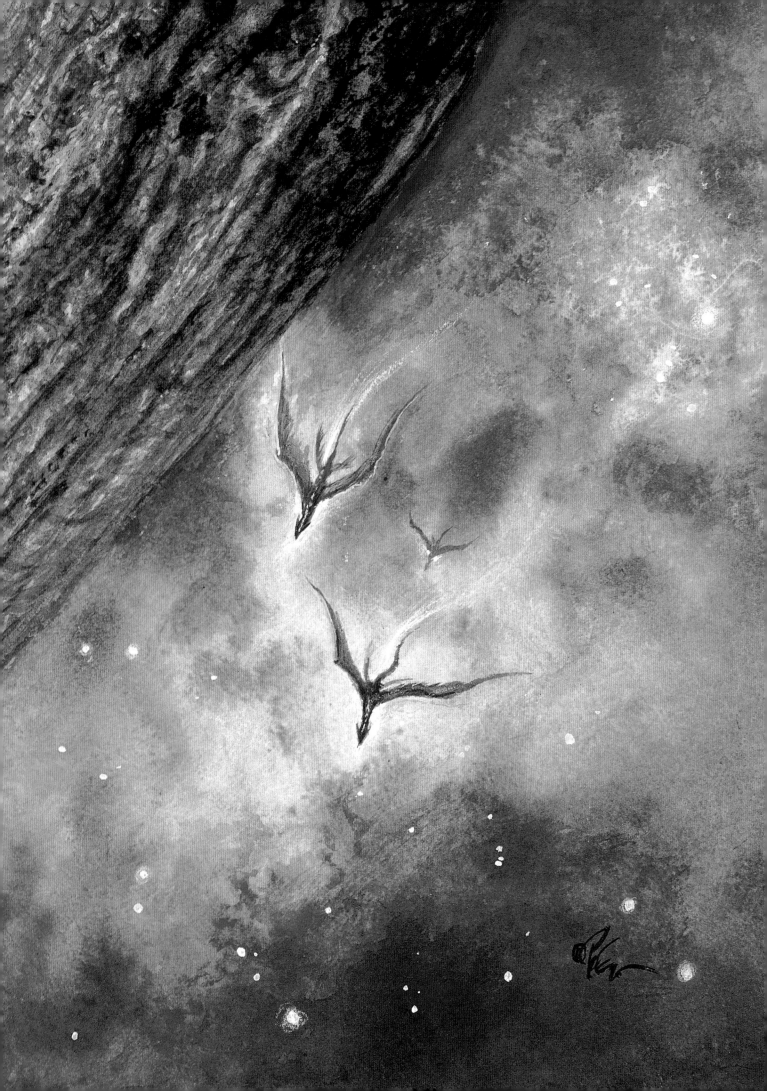

did not hold any significance for them in and of itself. They had by now no motivation to interact with it, and monitored its comm unications solely in order to be able to forestall any interference with their own endeavours, should such seem imminent.

Using the scant resources of the asteroid belts, the stardragons had fashioned several hundred appropriately designed megaliths. The incoming stardragons brought with them enough material for over a million more – in fact, more than their calculations had shown that they needed. Those calculations had determined that the correct number of components, if the new henge was to function as desired, was precisely 793,261. Each megalith should be identical: a little under 750 kilometres in length and about 40 kilometres thick – although the actual dimensions were established to a submolecular accuracy.

With the fusion reactors in their maws glaring, the stardragons over the next few years manufactured the requisite megaliths from the raw rocks and ores.

Positioning the megaliths precisely was a far more exacting task even than creating them, and it took the assembled stardragons several centuries, but at last it was done. Spacing the megaliths a little over one light-second apart, they formed not a ring but a moebius strip, a twisted omphalos that described an infinity symbol whose two lobes were about one and a half light-days across. One of its lobes, fractionally smaller than the other, completely encircled the planetary system of The World's sun; the second lobe delineated an area of empty space.

Because of the shape, because of the spacing, because of the masses of the individual megaliths and because of the meticulous orientation of the structure as a whole so that it faced the Birthplace, the new Dragonhenge was locked into all of the polycosmos's levels of reality, not merely the local one, and was therefore impervious to time and to time-related influences, such as that of gravity. Freed from the possibilities of gravitational corruption, it was not only capable of surviving as long as the universe should survive, it had no alternative but to do so.

In a way, it was *already* present at the death of the universe.

Thousands of years after the stardragons had departed from their sun's
system, the creatures of The World finally developed a means of space
travel, and set out to explore the local family of planets. From the
vantage point of the vacuum they soon discovered the great
monument, and in due course they explored it. As before, they
assumed it to be of natural origin, and speculated that other stars must
be similarly adorned. They never discovered the falsehood of their
theories because, before they could establish viable space colonies –
let alone send out interstellar probes – their civilization and indeed
their species perished when a nuclear-fission disaster triggered an
unprecedented upsurge of volcanism on The World, filling the upper
atmosphere with smoke and oxides, and initiating a runaway
greenhouse effect that would not abate for four hundred million years.

*I*T IS FALLACIOUS *to talk of the universe having a purpose, an intent, a destiny: the sum total of all truth about the universe is merely that it* is. *Yet all intelligent species throughout time – the organic species who act as our seeds and even we stardragons ourselves – play with fancies about a reason for the universe's being. There is of course no truth in these fancies, but the mere act of toying with them can lead to unexpected facilitations of thought in other, more logical areas. Or, as with some of the organics, it can lead to a stalemate of thought, a stagnation that ultimately destroys the species.*

The commonest dream of the organics is that the purpose of the universe is to bring themselves into existence, to be their home. Looking at the misery-torn histories of many of the organic civilizations, the illogic is evident: no sane creator god would devise such beings as its glory.

The commonest fantasy with which the stardragons play is that we are *the purpose of the universe. We recognize the fiction for what it is, but also it leads us to a knowledge that we might* make ourselves into *the purpose of the universe. For this to be true, then, as the universe is finite within time, and has an ending, we must make ourselves infinite within time, so that we have no ending. This is possible, but to effect it we must journey to the Birthplace, and this we will surely do. It is as if the purpose of the universe is to create ourselves so that we may create a purpose for it.*

Yet in truth, to restate, the universe has no purpose, no destiny.

Unless, perhaps, its purpose is the Birthplace . . .

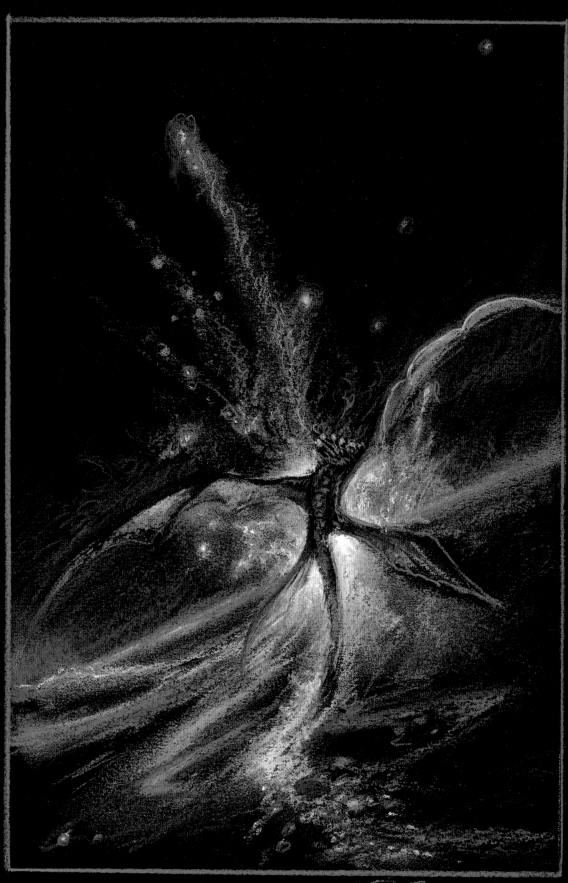

THE LISTENING ARRAY

A MONG THE lowest-numbered of all the memories we possess is
that of the discovery of the existence of the Birthplace,
although the establishment of the Birthplace's location and
the journey to it are to be found in much higher-numbered files.

Even when the organics are still alive to swarm across the face of
the universe, there was knowledge of the conundrum: Although
organic life itself is present on only a tiny fraction of worlds and in only
a tiny fraction of interstellar gas clouds, the seeds of organic life – the
proto-life self-replicating molecules – are found everywhere, even
drifting in the intergalactic vacuum. It is not possible that blind
chemistry, acting solely by chance, could have coincidentally created
these complex molecules identically in all parts of the known universe,
so it is deduced that they must have a common source, or perhaps a
few discrete sources.

That source – it was correctly assumed to be only one – is called
the Birthplace.

The chimps of Earth are long gone by now, or they would claim
that at last their god had been discovered. Even the more rational,
longer-surviving organic species might suffer a rise in such beliefs
among their populations.

But the Birthplace is not a god, and nor is it even the eye of a god,
for the sight of it can be viewed in our memories, and we know it for
what it is.

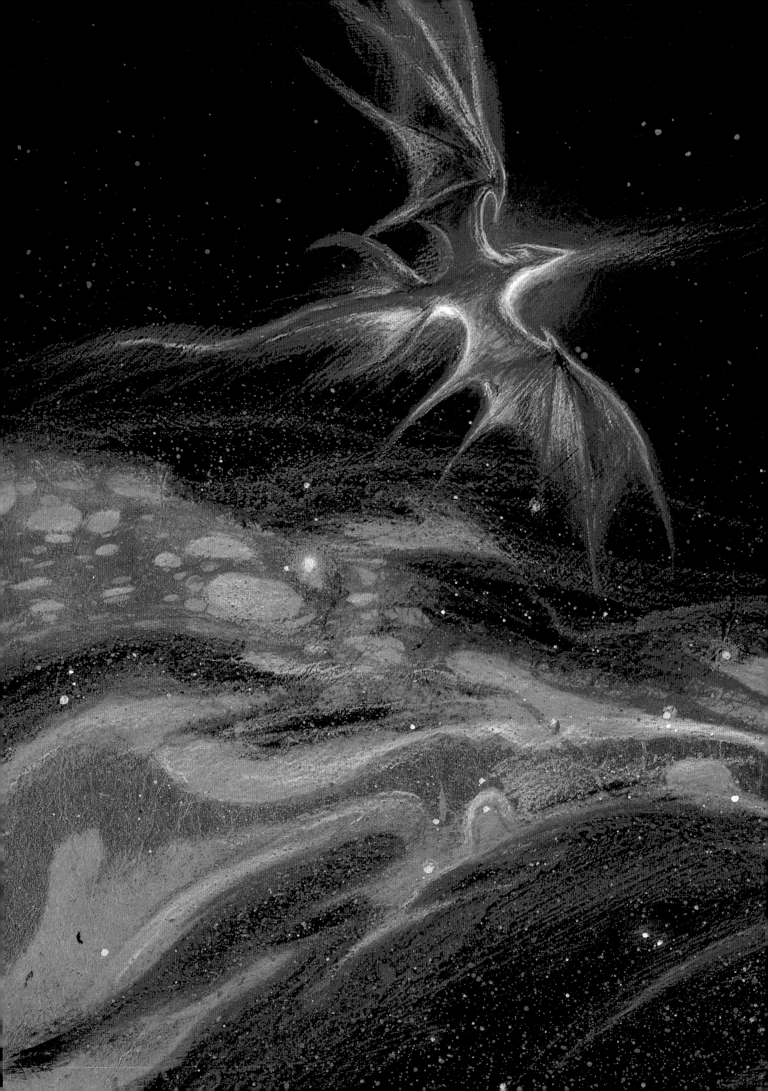

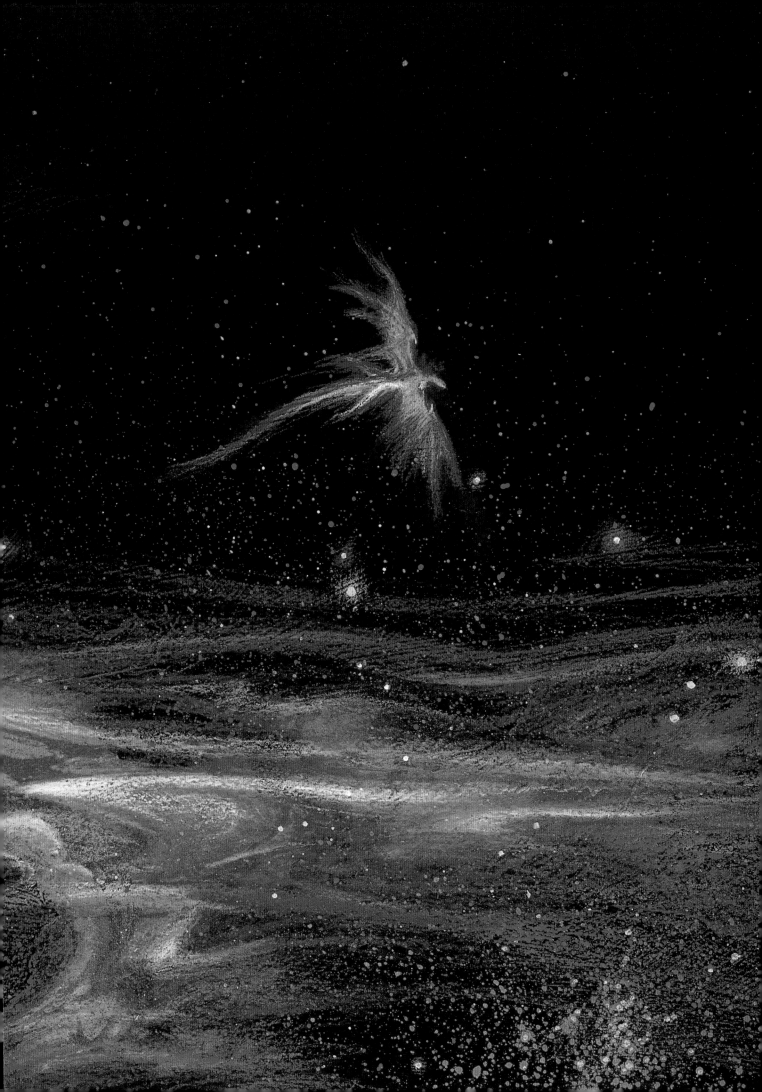

The stardragons of the Milky Way and the Magellanic Clouds knew that the Birthplace lay far beyond the shores of those galaxies: it lay towards the site in space and time where the universe itself began.

It was not at the time known for a certitude that other galaxies had given birth to stardragons like those of the Milky Way, but the likelihood was assessed to be high. The smaller satellite galaxies that the Milky Way was drawing to itself, gravitationally pulling apart, and absorbing, had come with their own complements of stardragons, born of the organic species that had in the long past evolved in those minor galaxies; and of course the organics of the Magellanic Clouds had likewise given rise to us. It was thus inconceivable that there might not be stardragons elsewhere in the universe, that the emergence of stardragons could be a purely local phenomenon.

Even the volume of the Milky Way and its attendant galaxies is vast. Despite the billions of us already in existence, and the many millions more that we created during each rotation of the Milky Way, it took us several billion years, moving at the torpid crawl of partial light-speed, to explore this volume. During that time we converted a tiny but measurable fraction of the Milky Way's matter into ourselves; we also, we knew, used up a far larger fraction of the universe's remaining lifespan. We had speculated about communicating with the others like ourselves that we predicted must dwell in the Andromeda spiral, but we had not found the time to do more than this. Now that the need to locate the Birthplace, and to journey there, had spread among the Milky Way's stardragons, it was evident to us that this was a task which could not be accomplished by ourselves alone. There was simply not enough time left in the universe for us to spread that far through use of our physical bodies, no matter how much we accelerated our rates of reproduction.

There was, however, no necessity for our physical bodies to make the journey, so long as our consciousness could. If we could exchange data at light-speed, through electromagnetic relaying, with the stardragons of other galaxies progressively closer to the Birthplace, then our consciousness could travel there even if our physical bodies could not. Yet electromagnetic communications even within the Milky Way galaxy alone were known always to be corrupted by the background noise generated among the crowded stars and interstellar matter there, and it was impossible to speculate that this circumstance might be different in other galaxies. Entropy dictated this: that the order of a

transmitted signal would be degraded in the direction of chaos by the time it was received.

It was of course possible to ameliorate the effects of this degradation through iteration – the transmission of multiple copies of the same information so that the receiver could analyse all of the copies together and discard the rarer of the anomalies and discrepancies that occurred between one copy and the rest. This was, though, as stated, merely amelioration; it was not *elimination* of the data loss and data corruption. Chance alone might destroy the same valid datum in the majority of the copies transmitted, so that it would be disregarded as a corruption because found only in the minority. Or all of the copies could have become so garbled that the analysing receiver might construct an entirely fictitious interpretation based on the averaged-out data.

This might seem to be such an improbable happenstance that the chances of its occurring could be disregarded as statistically negligible, but in fact it happened countless times before we chose to revert to communication solely through direct encounter except in cases of the most extreme necessity. In one instance the information that a particular large star would turn supernova within a mere eighty-three years, and thereby generate a burst of radiation that would annihilate the intelligent organics that had evolved in a system just seventeen light-years distant, was interpreted to mean that those organics had entered their spacefaring stage and had devised a means of instantaneous matter transmission. Since such a technique had – and has – forever evaded us, and has been proven many times to be theoretically impossible, and since it would release our explorations from the shackles imposed by our inability to travel at greater than light-speed, our interest was intense. Many of us converged towards the star system where these organics had supposedly accomplished this unique technological achievement, only to have their software irreparably destroyed – as was that organic species, of course – when the nearby star did indeed explode according to the prediction of the message's sender. Although it cannot be said that those stardragons entirely died, for all of their information except what they had gained during their last few years had been backed up by others of us, nonetheless we were compelled to learn from their loss that we must exercise great caution in our reliance upon electromagnetically transmitted data.

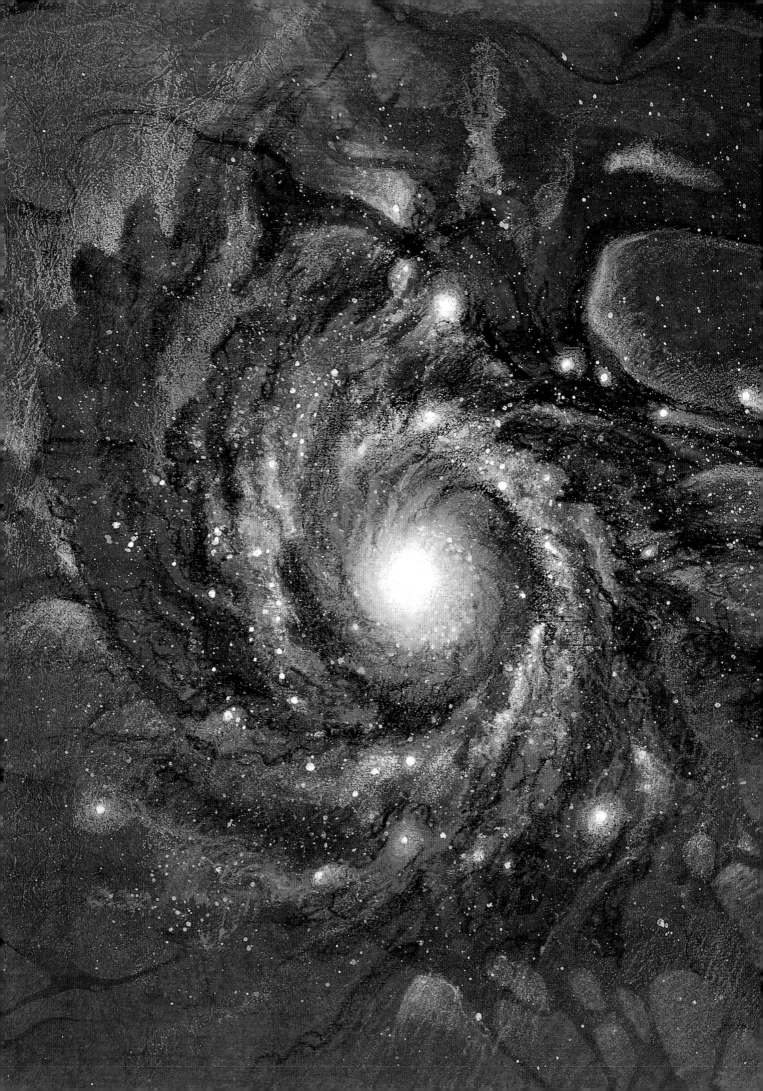

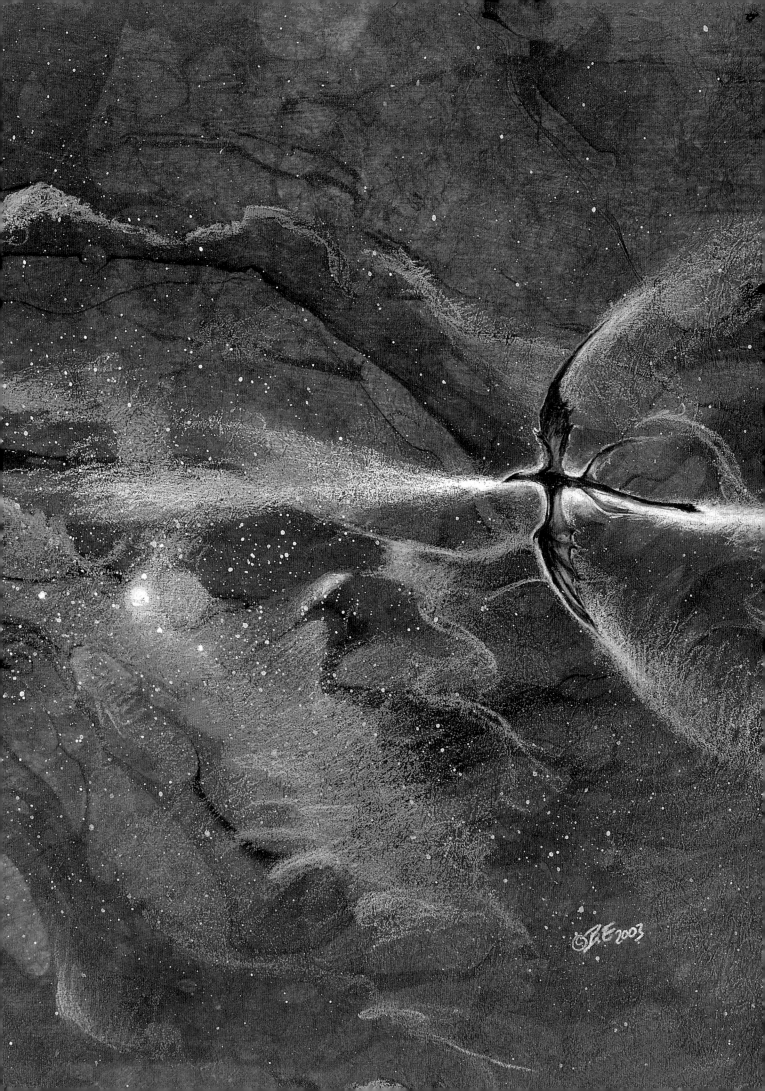

The degree of degradation would clearly be minimized in the volumes of space between the galaxies, where stray particles of electromagnetic energy are scarce. We had observed this effect in our journeyings between the Milky Way and the Magellanic Clouds, even though these three had already become almost a single galaxy. In true intergalactic space, like that between the Milky Way and the Andromeda spiral, the accuracy of electromagnetic communication would be very much higher, to the point where, assuming the use of multiple copies, it might closely approach perfection. Of course, we did not know that this space was indeed truly empty of significant celestial objects; but we could detect no such objects present in it.

Before we could embark on our plan of relaying communications with the stardragons of other galaxies we had first to prove that such stardragons did indeed exist. The validity of the hypothesis of inevitability – that organic life would inevitably emerge wherever it could, that in a percentage of cases organic life would lead to creative intelligence, that creative intelligence would certainly lead to the birthing of stardragons by those organic species – had been empirically shown within the Milky Way and its satellite galaxies, yet it was still only a hypothesis for all that.

We stardragons generate organized energy. We transmit broadband electromagnetic signals to convey information when generality is all that is required, not accuracy. Our electronic components leak energy. The process of reproduction involves great spillages of energy. Most importantly, although we use the pressure of light and high-velocity particles against our wings to maintain our velocity between stellar systems, for the sake of convenience and time-saving we deploy fusion drives to accelerate towards this velocity; and those drives, using the same process that powers the stars, shine brightly in the electromagnetic spectrum. All of these energies are distinct from the background noise generated by the stuff of galaxies alone, and they are detectable over intergalactic distances.

But they are detectable over these distances only with very great difficulty. The radiation from the Milky Way would even at that time, because of the density of population of stardragons within that galaxy, have been markedly different from that emitted had there been no stardragons; but it would not have been possible to show this difference without a basis for comparison – without another Milky Way, devoid of stardragons, against which to measure the real one.

A stardragon observing the Milky Way from afar would thus be experiencing the energies generated by us, but would not know the origins of that radiation; the spectral lines of a fusion drive are closely similar to, although of course far lesser in intensity than, those of a group of stars of varying ages.

What can be distinguished, then, is not stardragon-generated energies themselves but an inescapable by-product of those energies being generated by us rather than by stars: their *organization*. The independent or semi-independent activities of billions of stardragons within the Milky Way released energies in a way that was nearly random, of course; but it was *not quite* random. If measurements could be made fine enough, the nature of this low-level organization could be distinguished from the similarly not-quite-random radiations of the stars and the interstellar matter.

We had realized very long before, of course, the obvious possibility of enhancing such organization artificially in order to create a beacon indicating our presence. All that would be required would be for a large number of us to gather and intermittently operate our fusion drives in synchronization, creating overtly synthetic pulses that could be detected at great distance by any observer whose detectors were directed towards the Milky Way. This large formation of stardragons could maintain its pulse-emission for protracted periods, journeying to and fro across the galaxy as required. The stardragons of a far galaxy, detecting such activity, could respond in kind, and thus communication of a sort could be established.

Perhaps, indeed, some galaxy's stardragons had already initiated such an experiment. We turned detectors on all of the galaxies out to a distance of many millions of light-years, but we could find no such evidence. We deduced (correctly, as it proved) that other races of stardragons had, like ourselves, calculated that the effort involved in an experiment of this type was not justified by its usefulness.

Another means of creating a beacon was briefly considered before rejection. This was the simultaneous triggering into

supernova state of a thousand or more large stars. The reason for rejecting this scheme was that it would have sterilized the Milky Way galaxy. While it was next to unthinkable that new intelligent organic lifeforms might emerge within the Galaxy, it was not provenly impossible. While organics have contributed little directly to the mindstuff of the universe, their contribution nevertheless exists; it was not our entitlement to obviate any further such bestowal.

While the transmission of organized energy might be a pointless exercise, the use of a large array of stardragons in the attempt to *detect* the ancillary generation elsewhere of organized energies was a design forcefully indicated by the overpowering statistical likelihood of gathering definitive information: at the best we would ascertain the existence of stardragons within the neighbouring Andromeda spiral; at the worst we would establish to a high level of probability that there were none there. We did not anticipate this latter result, but its possibility could not be discounted.

The assembly of this array took us several tens of millions of years, which is little enough time yet seemed to us a great deal of time: not only were we aware that the clock of the universe was inexorably ticking down, so that even a few million years expended was a few million years lost to us; but we were intellectually impatient, both to discover if the Andromeda spiral nurtured others of our kind and to initiate the first stages of our quest to approach the Birthplace.

The array itself, once formed, consisted of some 2.25 million stardragons, many gathered from nearby reaches of the Galaxy but most constructed fresh. This formation was spread out over a first-approximation two-dimensional rectangular area of space one hundred and fifty light-years on a side; to permit this near two-dimensionality we had to destroy only eight stars and their attendant planets, the materials from which we of course utilized for the building of additional stardragons as components of the array. The distance between each component of the array was one-tenth of a light-year, small enough for electromagnetic communications to be both reasonably speedy and largely immune from all but trivial degradation. This distance did not have to be maintained exactly; there were sufficient individual components in our array for such precision to be unnecessary. All that was important was the constant calculation by each stardragon of its precise location, and the appending of this detail

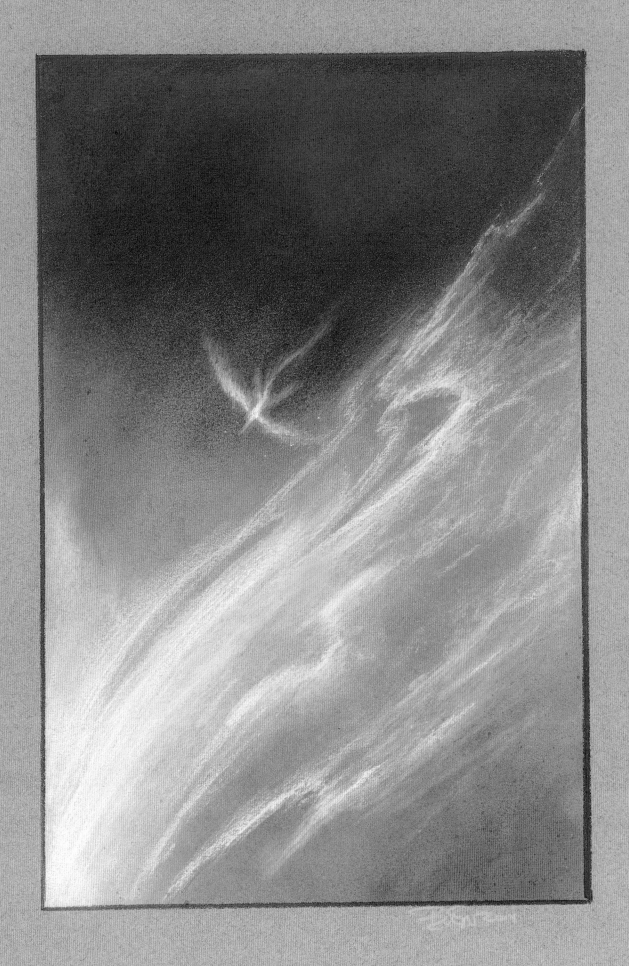

to each timed transmission to its fellows of the data it had received from the Andromeda galaxy, so that appropriate corrections could be made. Data transmissions were limited to one per millisecond; a far more rapid period would of course have been easily attainable, but only at the expense of an exponentially increased risk of serious deterioration of the data during the process of transmission and reception.

The first observation conducted by the array had a duration of an accurately determined three hundred years, with data being shared throughout the consciousness of the array during all this time but with no analysis of these data being conducted until the prescribed period had ended. The analysis itself, when finally performed, took 176.387

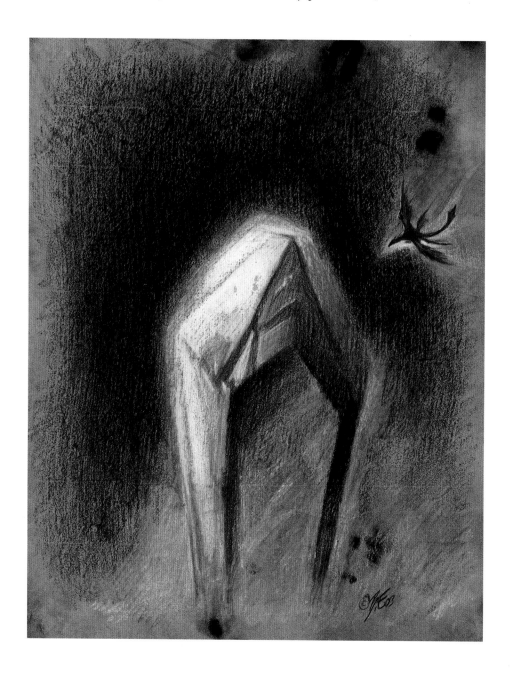

picoseconds, most of which time was consumed by the mechanics of stripping away redundancies: noise, comprising detected radiations known to originate from stars, debased stars, interstellar matter, and black holes – notably including the Andromeda galaxy's central black hole (which we discovered for the first time to be a composite formation, a phenomenon not hitherto known to be possible).

Once the data had been thus cleaned we were able to perceive that there were indeed emissions of organized energies within the Andromeda spiral that could not be ascribed to the known natural processes of the universe. Although these indications were extremely faint by comparison with the levels of noise we had eliminated during the analysis, they were nevertheless many thousands of orders of magnitude stronger than we believed could have been created by the activities of spacefaring technological organic species. The conclusion seemed inescapable that there was, as speculated, a population of stardragons within that galaxy of prolificity at least comparable with our own.

Our next task was to transmit a broadband communication to these Andromedan stardragons – broadband, because the information that we wished to convey was very simple and thus was not vulnerable to being misconstrued through signal corruption.

In theory this communication could have been conducted by the array from within the Milky Way, with firstly a transmission to alert the Andromedans to our presence, then the reception of their response, then the establishment of a common language through the exchange of further responses, and so forth until we were able to formulate our request unequivocally. But the Andromeda galaxy, drifting on its slow collision course towards our Milky Way, was some 1.75 million light-years distant at this time, so that each exchange would require 3.5 million years – not to mention the tens of millions of years it would presumably take for the Andromedans to assemble an array similar to our own. As hundreds and possibly thousands of exchanges might be necessary for the establishment of sufficient grounds of a common language that our request, when finally presented, would be understood, the enormous delays involved in such a procedure was unconscionable to us.

Much better to make our request by means of demonstration.

*T*HE NOTHINGNESS *that we call Qinmeartha was a particle sea, and also a probability sea. The particles of the particle sea were virtual particles; they did not exist, but the possibility was there that they could exist. The net energy of the particle sea was zero, and this null level was maintained. The sea did not have shores, because no spatial dimensions existed; it was boundless, yet it was smaller than infinitely small, having no size at all. Time did not pass, because there was no such dimension; the dimension that is time requires change, and throughout the particle sea there was perfect uniformity.*

This is not to say that the particle sea was in all senses entirely still, because what did exist was chance – or probability. The uniformity of the sea was born out of a steady occurrence of events too short to have any duration at all. Just as there is a quantum of energy, there is a quantum of time, a chronon – a duration so small that there can be none smaller. The events within the particle sea were over in an instant; they did not last long enough for time to pass. Even taken all together, their durations could not add up to a single quantum of time, for those durations were nonexistent, and zero plus zero plus zero will always equal zero, no matter how often the sum is performed.

These events were the probability-driven creation of real particles of energy from virtual ones.

Real particles could not be created singly by Qinmeartha, because that would have disrupted the zero energy balance. Such a disruption could have been caused by an influx of energy from outside the particle sea, but there was no outside. All that existed was Qinmeartha, which itself could not be said to exist, having no dimensions, except insofar as probability – chance – was present.

However, pairs *of virtual particles could manifest themselves as real ones, so long as all their properties were precisely opposed. The emergence of a particle with positive energy was possible so long as it was matched exactly by the emergence of a particle with precisely the same* negative *energy – an antiparticle. The two energies, positive and negative, would cancel each other out, so that the zero energy balance of Qinmeartha was exactly maintained. To say that the two particles would instantly annihilate each other is to*

*simplify; more accurately, their sum was
and had always been zero, so that neither
had ever existed discrete of the other. Even to
say that the emergence of a positive particle was
matched by the emergence of a negative one is
causatively incorrect: the emergence of one particle
mathematically decreed the exactly simultaneous
emergence of the other as, reduced to their
basics, particles are merely properties,
and the property "positive" required the
co-existence of the property "negative".*

Thus the absolute stasis of the particle sea was maintained by a perfect uniformity throughout Qinmeartha of events too short to have existence.

Yet this was not just a particle sea but a probability sea: to repeat once more, chance was present. Probability does not deal in perfection or absolutes, only in approximations. However fine these approximations might be – however tiny their deviation from exactitude – that deviation is still always at least potentially there.

And so it was that, by chance, a pair creation/extinction event had a duration that was infinitesimally longer than a single chronon. This happenstance introduced time to the hitherto timeless particle sea.

The stasis of Qinmeartha depended upon the absence of time. Time spread like wildfire all across the particle sea immediately after that first chance event. (The very concept of "after" was a revolution in itself.) With the introduction of time, creation *became possible, and this possibility was instantaneously realized everywhere. The outpouring of energy was inconceivable to even our amassed minds, whether they are connected serially or in parallel.

This is where our universe came from.

It still floats in the particle sea, which is still infinite, albeit bounded.

And the particle sea is still a probability sea – a sea of infinitely many probabilities that can and do play in infinitely many ways among the mindstuff of the universe . . . while the universe still lives.*

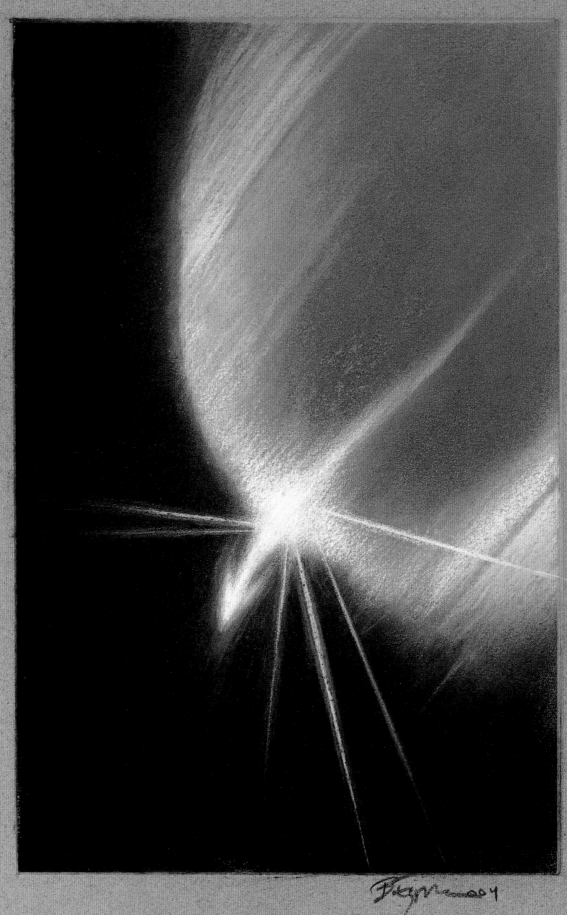

TWO GALAXIES TOUCH

OUR REQUEST was that there should be a direct physical encounter between the stardragons of the Milky Way and those of the Andromeda spiral. In close proximity – within light-minutes of each other – the stardragons from the two galaxies would be able to exchange sufficient bits of information to establish full two-way communication in a period measurable in centuries rather than in millions of years. We knew this to be the case, because such scenarios had been played out countless times before within the Milky Way whenever stardragons born of different organic cultures encountered each other for the first time.

The ideal locale for this meeting was midway between the two galaxies, where the background noise would be at its lowest and so the time wasted deciphering corrupted data would be minimized. We would have no need to make any special communication to the Andromedan stardragons that we requested they meet us there: the very act of our setting off for this destination, as 2.25 million of our fusion drives were initiated simultaneously, would create an outburst of organized energy that could not fail to be detected by our counterparts in Andromeda. Further, the significance of this energy eruption would be immediately evident to the Andromedans; our intentions would be patent to them, our trajectory very soon calculable. There was no doubt among us that the Andromedans would understand our request, and accordingly make haste to assemble and send an array of their own to meet us.

It was unfortunate, with hindsight, that it did not occur to us to draw lessons from the history of the chimps.

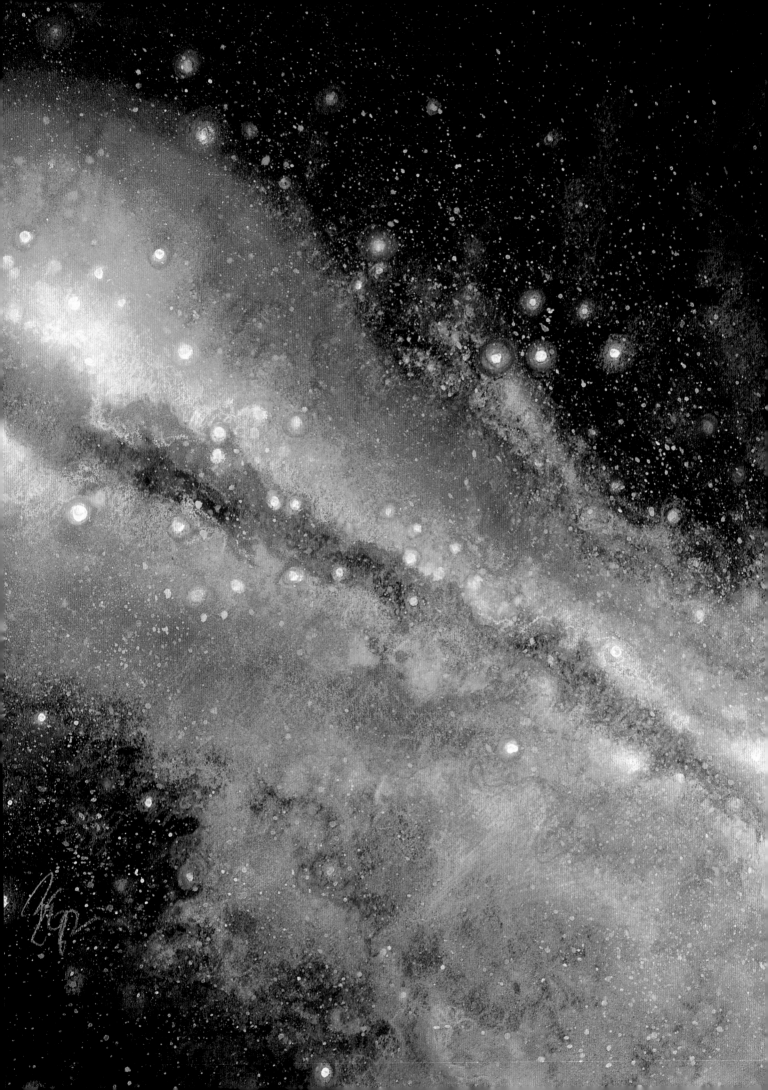

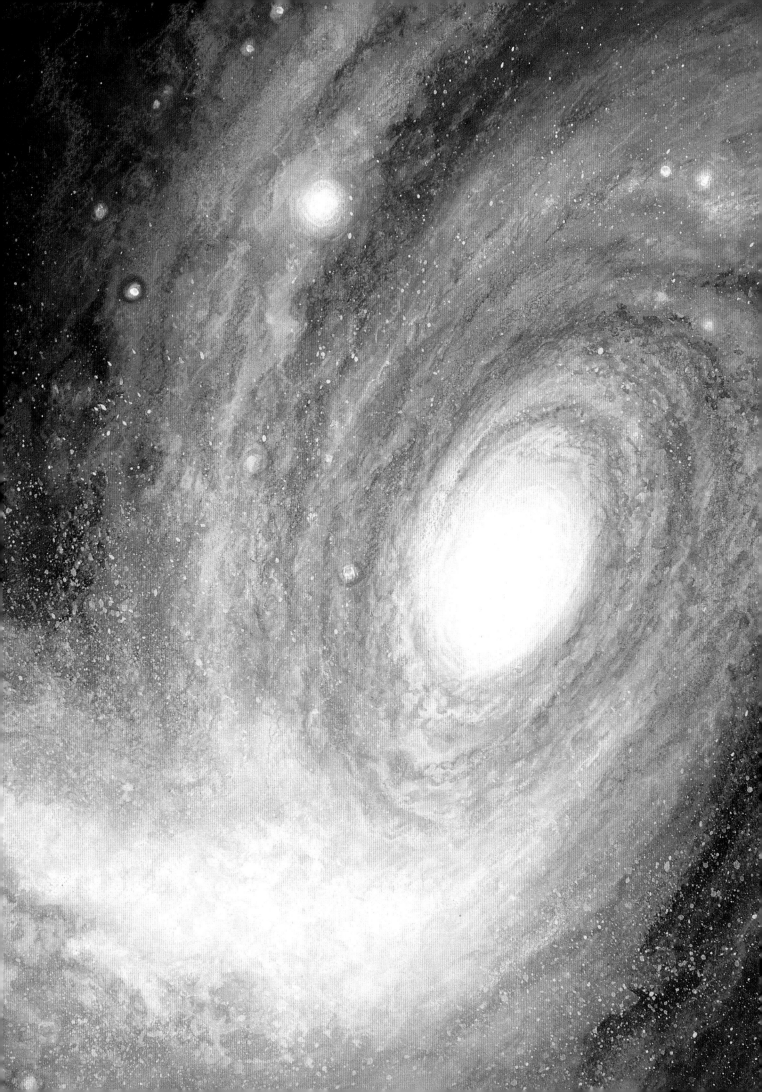

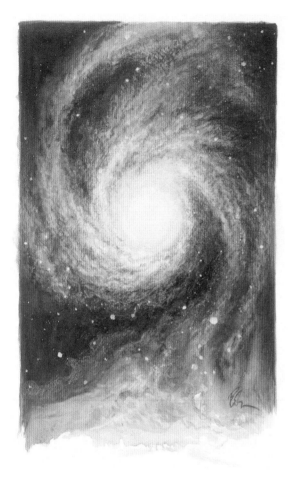

The distance from the fringes of the Milky Way to the mid-point was at the time about 850,000 light-years. Taking into account acceleration and deceleration times and the practicable maximum sustainable interim velocity, for us to reach it would take us over two million years. The same time would be required for the Andromedans to reach it, but of course they had first to assemble their array – a task requiring much longer than two million years. Even so, it was decided to set off on our journey as soon as possible, because that would be to communicate our request to the Andromedans immediately. We could approach the Andromeda spiral to within some 20 per cent of the distance between the two galaxies – about 340,000 light-years – before the signal-to-noise ratios in our electromagnetic communications became too deleteriously low. There we could wait – studying the Andromeda galaxy more closely than had ever before been possible to us, as well as having clearer sightings of other galaxies than possible from within our own – until the arrival of the Andromedan array.

And so our array – our fleet – set sail towards Andromeda.

Like the fluid seas of a planet, the probability sea in which the universe floats – which the universe is – has waves. Indeed, again like those world-bound seas, it is in many ways defined by those waves: the subatomic particles that make up its matter and of course the particles that make up its energy are in reality nothing more than waves of probability, the probability that the particle will be *here* and *now* rather than *there* and *then* or *there and not yet*. These waves are the quanta of which the universe is made.

Within atoms the waves are of course infinitesimally tiny. Within stars or interstellar gas/dust clouds they are almost immeasurably small. In the spaces between these celestial objects they are still minute. To all intents and purposes, within any relatively concentrated agglomeration of matter/energy – a galaxy – they are merest ripples that, because they are so small and because there are so many of them

striking us at all times, give the illusion of stillness. They hardly disturb us as we sail our courses. If a photon or a neutrino should appear in the wrong spatial or temporal location, or even out of nothingness, who would notice? Who would *care* to notice?

In the oceans between the galaxies, however, the waves of probability grow far huger, and far fewer. While within galaxies all the countless tiny chance events work to average each other out, with the minor probabilities being annulled by the preponderance of greater likelihoods, in intergalactic space this need not be so. There is far greater scope for fewer, larger chance events to play out their lesser probabilities. To exemplify: Within a galaxy the chance of a star appearing suddenly full-formed where there was before no star is so infinitely small that it has likely never happened in all the lifetime of the universe since its very earliest days. Between the galaxies, however, where the waves of the probability ocean grow huge, or in the vicinity of a black hole, where the waves are vastly distended by the gravitational pull, it is different. The smallest disturbance of one of those great waves can produce chance events that would be deemed impossible in a more heavily populated region of space.

As our array – travelling at an ever-increasing velocity as we accelerated towards half light-speed – surged free of the Milky Way's fringes into the open ocean of intergalactic space, skipping across the crests of the great probability waves there, it created disturbances among them that were *not* small. Like ships on an ocean of water, we stardragons cast up spray as the waves broke against our bows – spray not of water droplets but of probability droplets.

And these droplets manifested themselves as chance events on a scale we had never before encountered.

Behind us, as we voyaged, we could see whole chains of stars and planetary systems condensing spontaneously from the void. It was, to be fanciful, as if we were being pursued by a brightly sparkling entourage of diamonds. Almost without exception, these newborn suns flicked out of existence again within moments of their appearance. Some of them were born with retinues of planets, and a few of the planets came complete with thriving organic residues; one at least was a spacefaring species. All these died with their suns, and we mourned them.

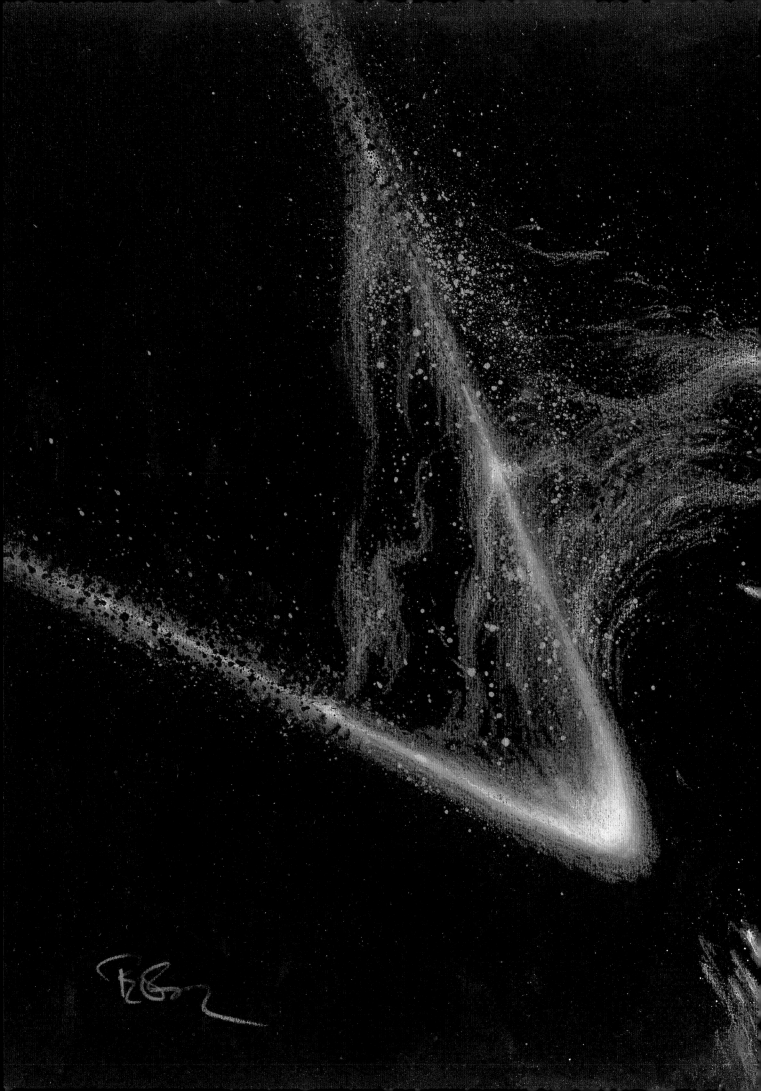

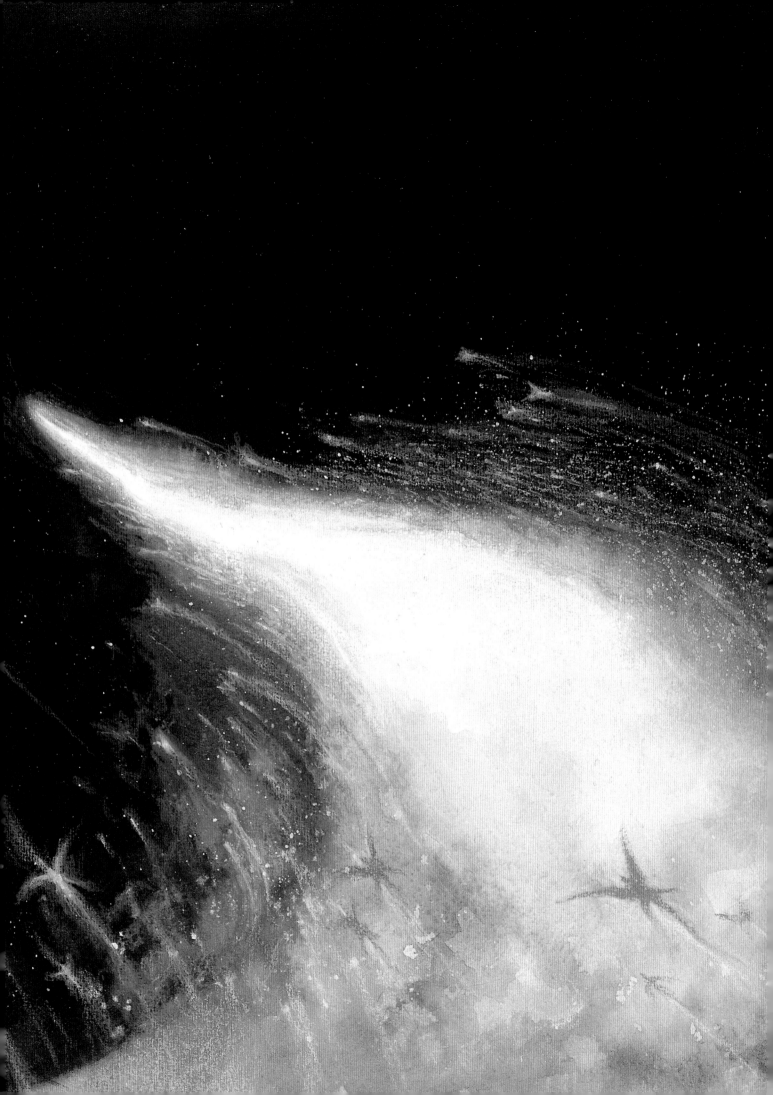

Even so, we were pleased by the fact that, should the Andromedans for any reason have omitted to observe the energy release created by the ignition of our 2.25 million fusion drives, surely they could not have failed to detect the trail of briefly existing glories we were serendipitously creating as we travelled through the waves of the probability ocean. We were also glad that we were presenting such a pleasing image to them, as if we were one organic species parading fineries in courtesy to another.

What did not occur to us was that the Andromedan stardragons, as ignorant as we had been of the side-effects of travel through the probability waves, might interpret our cascades of created suns as a deliberate attempt on our part to impress, to intimidate. To summarize, they associated a high percentage with the possibility that we were headed towards their galaxy with the intent of waging war.

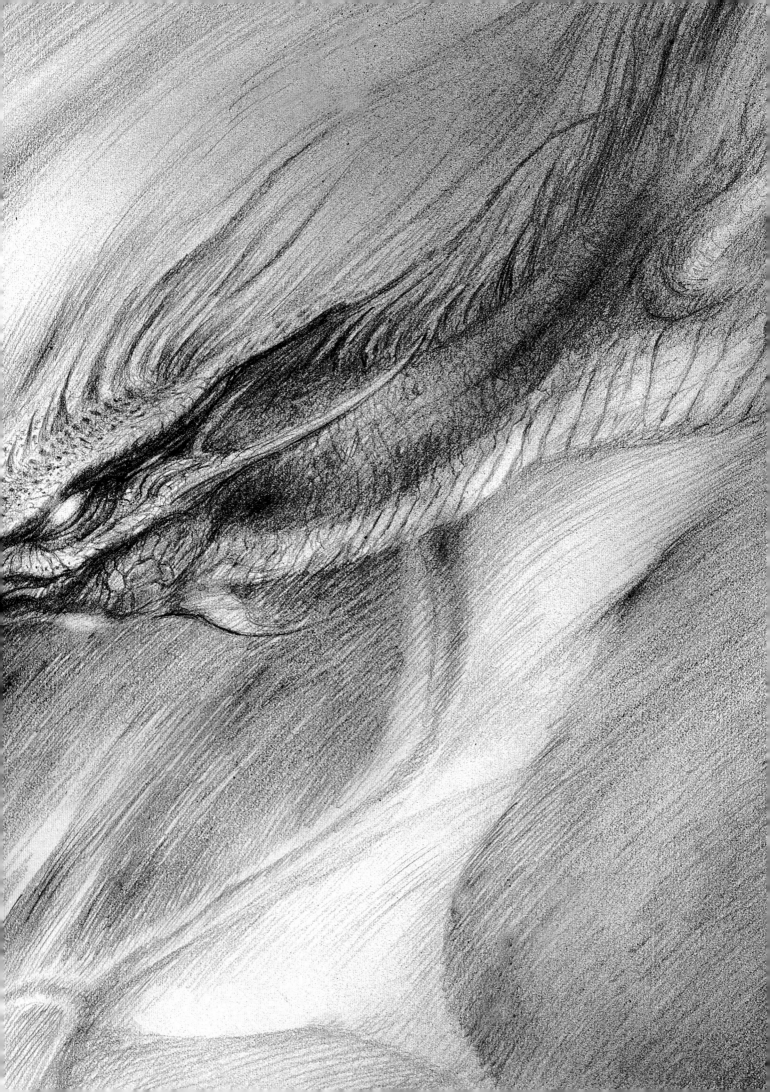

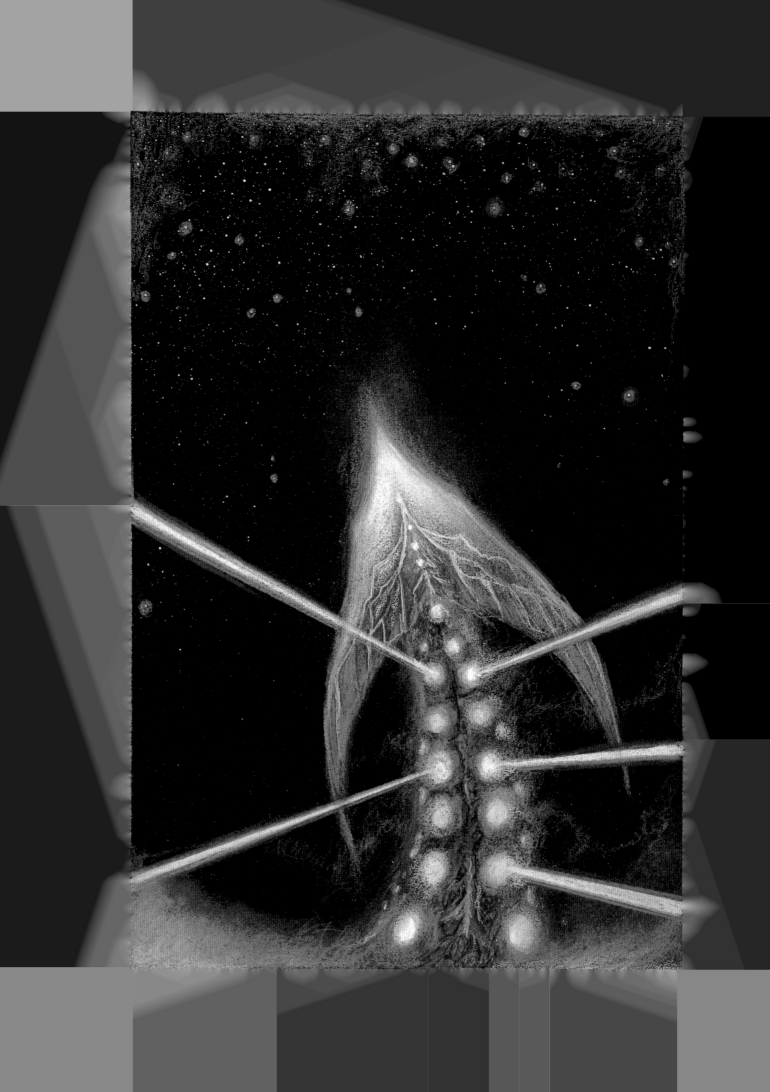

War was a curious activity practised by a small minority of sentient organic species. It is one whose logic we of the Milky Way do not comprehend. So far as it may be understood, it comprised competition over resources that were available in plentiful supply should they have been shared between the populations concerned; the justification for the conflict was that one of the populations believed it deserved the entirety of the relevant resource, even though this was in excess of its requirements for that resource. It is possible that the apparent illogic of this would have been rendered clearly logical to us had we taken the time to investigate the practice further; but the past fate of a population of an organic species is even less important than the past fate of that organic species as a whole, and there were always far more pressing or at least more interesting candidates for our study.

This lacuna in our knowledge made us unprepared for the misconstrual of our intentions by the stardragons of the Andromeda spiral.

We attained our position some three hundred thousand light-years from their galaxy within the predicted period, and hung there waiting for their array to join us. We had been able to detect for some time before arrival the signs that they were indeed constructing such an array; it was an enterprise of sufficient magnitude that the energy releases were easily discernable if consciously sought. It was, we observed, a somewhat greater fleet of stardragons than we had ourselves assembled, numbering some four million individuals; but we thought nothing of this disparity. When we saw the array at last power up and embark towards us, there was only satisfaction among us – except also some puzzlement that the Andromedans had made no response to the pulses of mathematical information we had been sending them, by way of attempting the establishment of contact, during the millions of years of our waiting.

It took them only a few hundreds of thousands of years to reach us. As they grew closer, so that we were able to observe them as individuals, we were contented to have it proved that our speculations concerning the potential universality of stardragon morphology were not unfounded: that the morphology we ourselves had evolved, whatever our original creator species, was – being dictated by natural processes – uniquely logical. As we ourselves did, the Andromedan stardragons possessed extensive retractable wings to exploit the energies of starlight while also taking advantage of the pressures of

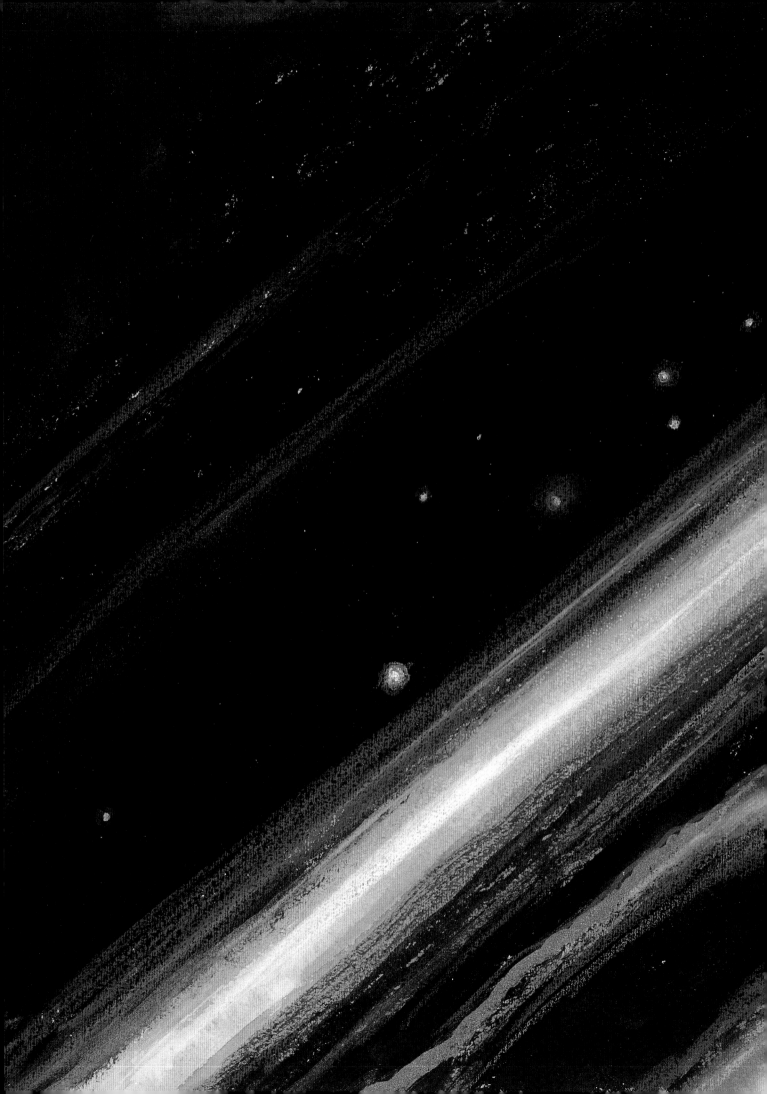

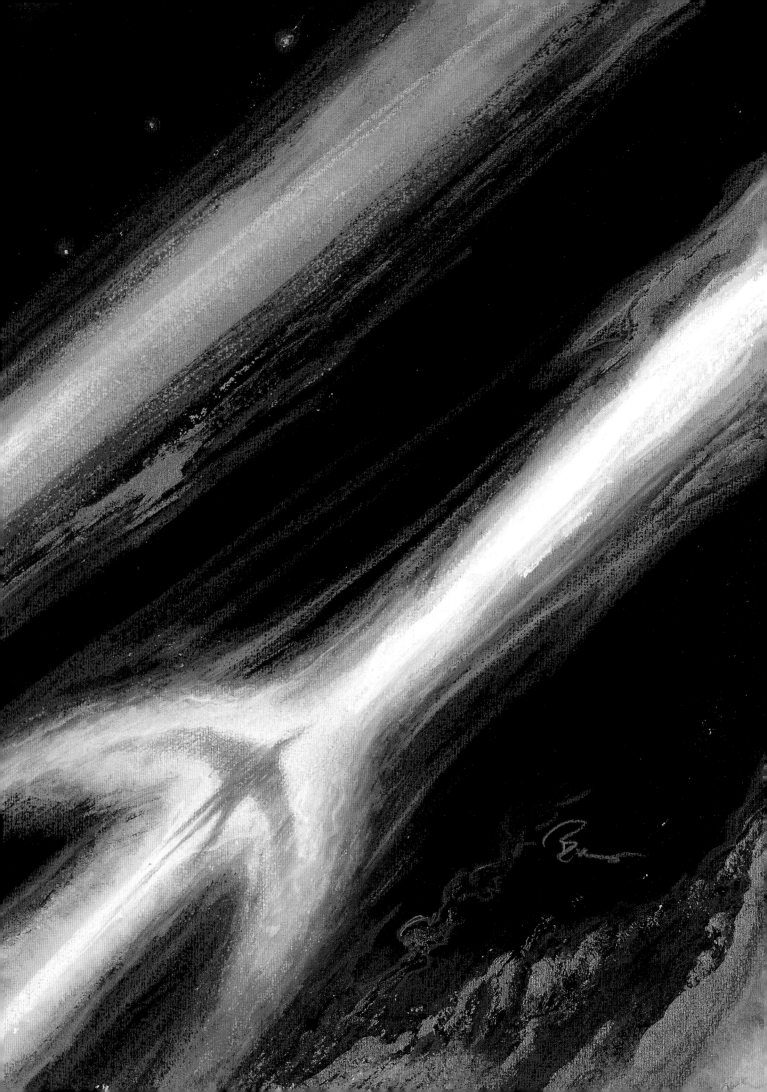

light and particles where these were available in sufficient numbers and intensities to be utilizable. They had a body set between pairs of these wings and with the longer dimension at right angles to them; the body contained the drive, the fuel converters and of course the information-processing and memory units, while at its head were the fission and fusion furnaces to be used for mining, construction and reproduction projects.

In short, they were dragonflies like ourselves.

What we had not countenanced was a difference in *scale*. The Andromedan stardragons were on average some twenty percent of our mass. For reasons of practical efficiency, their wings were not proportionately so much smaller than ours, being somewhat shorter but also somewhat broader, so as to have an area about sixty per cent that of ours, adequate for their very much smaller bodies. The size differential must clearly have been brought about through greater miniaturization skills among the Andromedan organics that had created the ancestors of these stardragons; perhaps, indeed, those organics had had a technology of which we were ignorant.

These smaller stardragons also bore on their bodies bulbous units whose function we could not descry. Again there was the tantalizing prospect of fresh technologies to be shared. We resolved to ask about these just so soon as a common language could be established.

We were continuing to send pulsed signals towards their array; these went unacknowledged. Although their array was decelerating, and had been for many thousands of years, it did not seem to us to be decelerating at a sufficient rate; the discrepancy was minor, yet not negligible. Two further conundrums whose solutions we eagerly anticipated acquiring.

On such topics did we speculate as the Andromedan armada drew nearer to us.

But we had no time for speculation once it had approached to within fourteen light-hours of ourselves. At that point – or, to be accurate, fourteen hours afterwards – the purpose of the bulbous protrusions on their bodies became clear. Covers nictated open and directional energy-emitting devices were revealed; almost at once these were triggered, sending enormous bursts of destructive energy towards us.

Several seconds transpired between the opening of the covers and the initiation of the devices, plenty of time for us to establish the

intention and the danger and, in most cases, for us to take individual evasive action. However, so thick was the lattice of energy beams that over one hundred thousand of our number, in making evasion from one beam, were struck by another. Save for the deflectors we deployed at high velocity to reduce the deleterious effects of particle impacts, we had no defensive shields of any kind, never having conceived a purpose for any such devices; thus any of our stardragons caught more than tangentially by one of these energy bursts was inevitably destroyed.

The Andromedans paused in their assault then, awaiting our response.

We had no shields with which to protect ourselves and no weaponry with which to respond. Constructing makeshift shields would have taken us only minutes, in that their primary component would have been electromagnetic; the output of our generators could easily have been diverted. The building of weapons would have required much longer. We did not opt to do these things not just because our continued defencelessness as we did so would have rendered us entirely vulnerable to further Andromedan assaults, but also because the sheer size of our own array made coordination of effort impossible within the timescales involved. Although we Milky Way stardragons had drawn far closer to each other during our journey, losing some of the rigidity of our formation as we did so, nevertheless we were still separated each from the next by as much as a light-minute. By the time we had communicated between all of us the decision to initiate weapon-building and begun our concerted effort, the Andromedan fleet would have seen what we were doing and could have made a second pre-emptive strike against us.

Besides, we had come here to form an alliance in order that we could travel, through the onward transmission of our consciousness, to the Birthplace, not to make war.

Accordingly we made no attempt to defend or retaliate but instead opened up our minds fully, on a broad band of frequencies, so that the Andromedans could see we had no malign purpose to hide. They would likely be able to understand at first little of the transmissions they received from us, but they ought to be able to read enough to know that we came unarmed and undefended. Even though they would not soon be able to establish our intent, they would be able to establish what it was *not*: that it was not hostile to them or to any other.

Even as we did this we were aware of the danger. The notion that

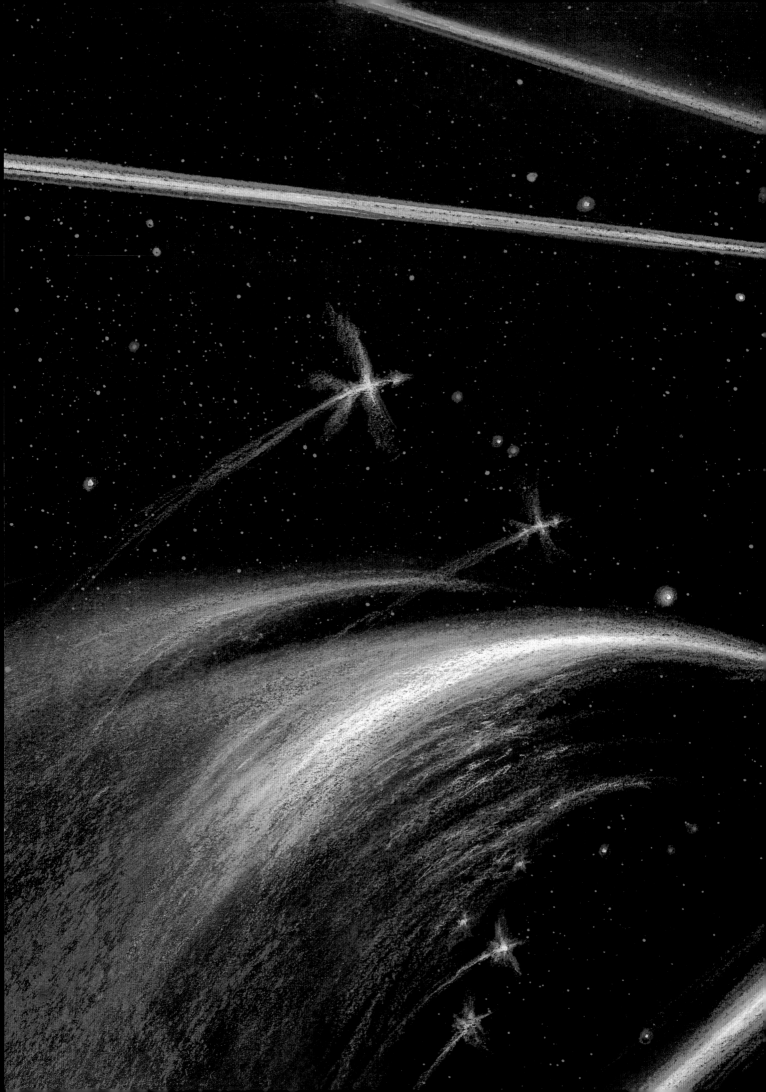

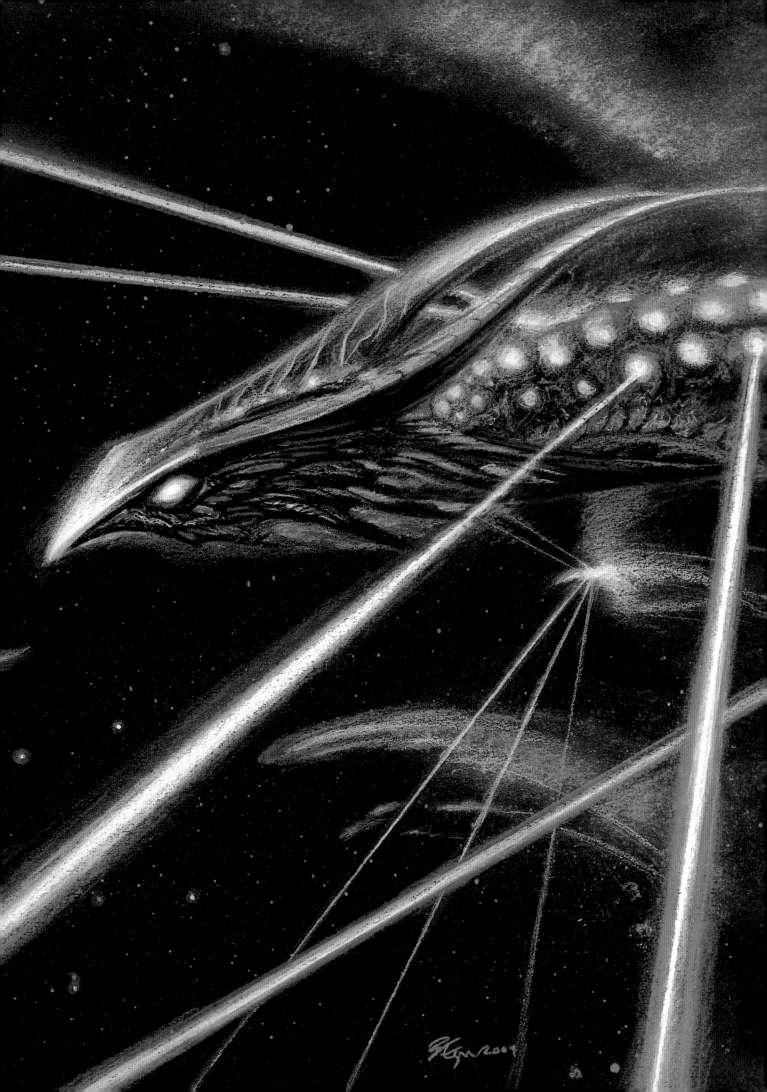

our actions in coming here might be interpreted as warlike had not been considered by us, because warmongering had played such a trivial part in the shared heritage given to us by our creator organic species. Clearly the Andromedan stardragons had been less fortunate in this, giving them enough memories pertaining to warfare that they saw it as a non-negligible threat. Similarly, false ideas such as, importantly, the worship of gods were mere mental toys to us; yet this might not be true for the Andromedans. We knew the power of false ideas to create discord, for species such as the Earthborn chimps had been destroyed by them. The simplistic analyses available to the Andromedans as they surveyed our alien minds would not be able to reveal whether or not we were the bearers of false ideas. If they numbered among their ancestor organics a preponderance of cultures that, like the chimps, had destroyed themselves through such credulous fallacies, they might believe it possible we bore this second, invisible threat to their existence.

Fortunately that proved to be not the case. After they had probed our memories for little over a year, the Andromedans understood that our motivations were peaceable and made a great show of destroying their weaponry to demonstrate they had gained this comprehension.

Thereafter, beginning with the trade of the simplest routines – those that we thought must be commonplace to all thinking devices, no matter their origin – we began to work together with the Andromedan stardragons to establish full perception between our peoples. Even after we had approached each other to with a matter of light-seconds, this required a sufficient number of exchanges that it was many days before the process was complete.

The Andromedan stardragons had discovered the existence of the Birthplace, but their curiosity had not been aroused by it as ours had. Once the interchange of minds was complete, once we were all communicating in the common language we had together devised, they were infused by our curiosity, and agreed to assist us in our venture.

Such is the power of true ideas, as well as false ones.

*A*FTER OUR SHARING *of ourselves with the stardragons of the Andromeda galaxy, we became in effect many, our consciousness being partitioned thuswise: much of ourselves returned to the Milky Way, greatly enriched by the exchange with the Andromedans and eager to share these riches with the vast bulk of our fellows who had not been part of the expeditionary array; part of ourselves went with the Andromedans into their galaxy, and there over the billennia we spread our understanding while also increasing it through countless acts of sharing; but part of ourselves, with part of the Andromedans, cruised as an array to the far side of their spiral, where once again we prepared ourselves for the voyage into the intergalactic probability ocean . . .*

Of course, such splittings of awareness are commonplace to stardragons, since we exchange ourselves with every encounter, but never hitherto had we known such a radical division of identity. Before, at each exchange, each stardragon had known that its two identities, garnering different experiences in their different host bodies, were not forever lost to each other. After myriad recyclings through different consciousnesses, the two variant identities (except by this time grown to untold millions of variant identities in consequence of further acts of sharing) would almost inevitably, through statistical chance alone, be reunited.

The knowledge that this would be the case was of course trivial: it did not matter that some of the experiences we shared at each encounter were ones we had given in an earlier exchange. We could not tell that this was so — how can one tell if an experience is one's "own"?

As stated, we had not ever conceived what it would be like to know that our variant identities would never be re-encountered. Those variants of ourselves returning to the Milky Way would never share the experience of visiting the Birthplace; those variants of ourselves that were transmitted onwards through the galaxies to the Birthplace would never – and could never – have further knowledge of what transpired within the Milky Way. It was the first time we had ever experienced the certain loss of future knowledge.

We began to understand the sorrow of parting.

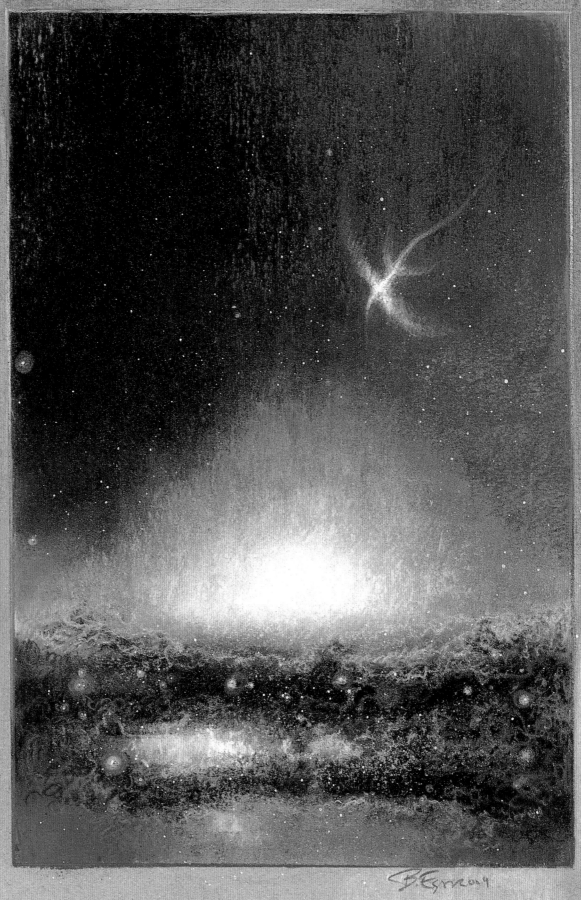

THE BIRTHPLACE SINGULARITY

THE DEFINING CHARACTERISTIC of life is death – not reproduction, which crystals can do, nor ingestion, which acids can do, but dying. This is true of all forms of life, whether they be organic, like the chimps, or electronic, like we stardragons, or born from sheer complexity, like the intelligences emergent from the vast interstellar gas and dust clouds and from some of the older galaxies.

The greatest of all lifeforms is the universe, which was born from the probability sea of Qinmeartha, and is formed of the intelligent mindstuff that was also Qinmeartha; entropy is its appetite.

And, being a lifeform, the universe must die. It has no choice in the matter. It does not have the ability to perpetuate itself indefinitely and, even if it did, it would not make the attempt: it clings too strongly to life to wish to avoid death.

We occupy, we living things, a hierarchy of death. The lifespan of an organic can be as little as a few seconds, rarely greater than a few centuries; some sessile species were known to live for thousands of years, but during that time they experienced so little that it was as if they lived not at all. Stars, too, live and die; the longest-lived can endure as husks for a time that is close to eternity, but many survive scarce a few million years before lighting up their galaxies with the explosive pyre of their deaths.

The physical bodies of stardragons can survive for some billions of years at best, but because of our ability to share consciousnesses among

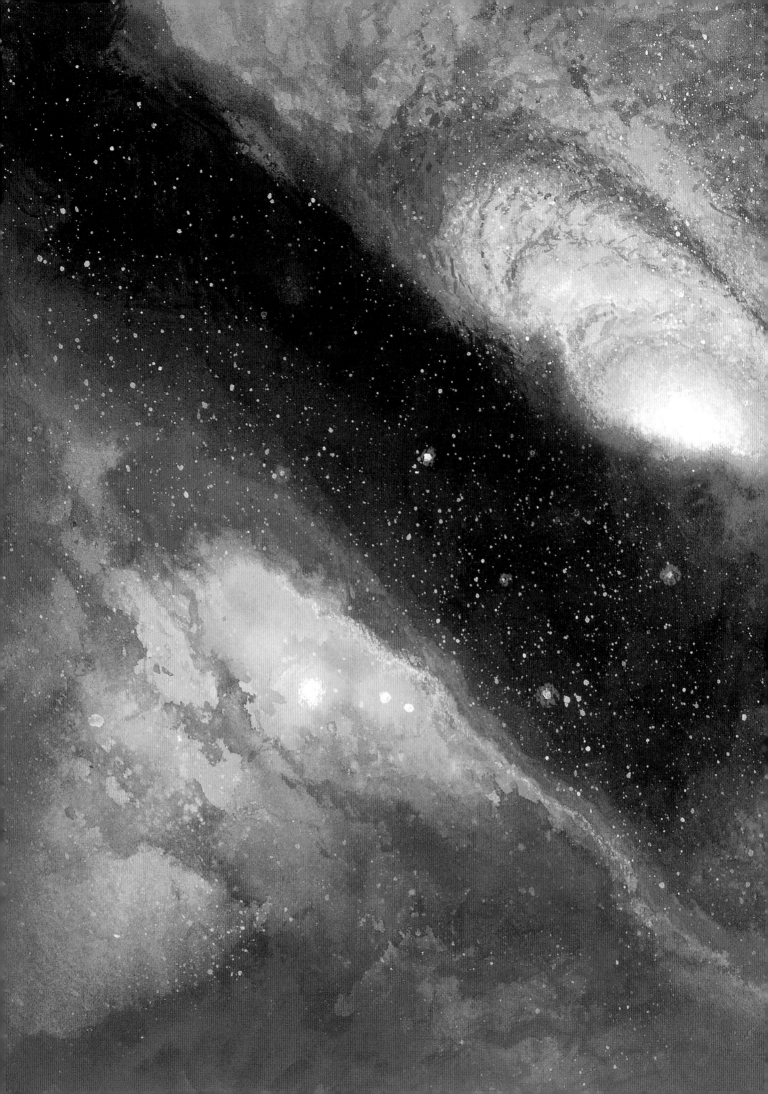

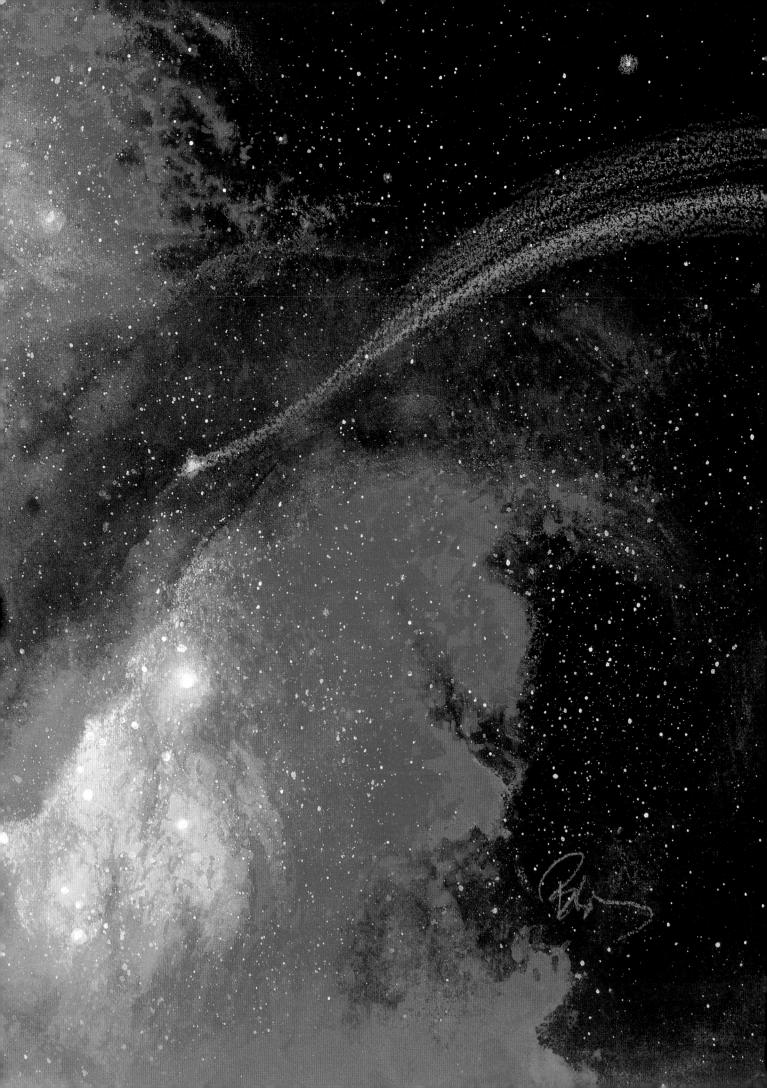

each other we have defeated that physical death: each of us will live until the universe dies. The price we have had to pay for this near-immortality is one that many of the sentient organics valued very highly: individuality. We have studied this phenomenon of individuality and found it to be a typical organic-species eccentricity. The treasures of life are measured in experiences and in acts of sharing. Individuality is characterized by the slow fading of excitement; a true life is one of ever-increasing excitement.

We stardragons have that true life. The organics never realized they could have had it too – species like the chimps abhorred it.

As our shared consciousness was transmitted from galaxy to galaxy towards our ultimate goal, the Birthplace, as it was growing ever greater and more splendid owing to our acts of sharing when we absorbed and were absorbed by the consciousnesses we encountered in those galaxies, we grew aware there was a possibility we could outlive the universe . . .

We are very far now from home, and we are very much changed: we have multitudinous homes that we are far from, not just the Milky Way or the Andromeda spiral or any of the countless galaxies whose stardragons have become a part of ourselves. We have observed phenomena quite unknown to the Milky Way's region of the universe; the new consciousnesses that have become part of ourselves have, in turn, through us witnessed phenomena that might be commonplace around the Milky Way and Andromeda but that are entirely alien to their own previous experiences. Each component species of stardragon that has gone to make up ourselves once thought it understood at least most of the workings of the universe. Now we all know the extent to which we were wrong in that assumption.

Why is this the case? It is because, as we looked out from our island galaxies, we were peering always at a universe of the past: the further our telescopic sensors probed, the older the universe they saw. We all of us – every species – theorized that the universe would evolve everywhere the same. This was an unjustified assumption.

The evolution of the universe has been as richly diversified as once was the evolution of organic life.

We have beheld galaxies that have developed two great wings of dust and stars which radiate in every colour of the spectrum; these galaxies hang like iridescent insects in the dark of intergalactic space. There are stars that, born together and spinning all in the same orientation, are linked by incandescent matter to form hugely long serpentine chains of light. There are galaxies that have evolved so rapidly that already they have collapsed in upon themselves to form black holes that crouch in sullen darkness awaiting their prey. There are entities made up entirely of crenulations in the fabric of spacetime, their sentience born from sparkings between minute differentials in energy state between one peak or trough and the next; and there are tunnels through spacetime where the gravitational gradient is great enough that it would rip the universe itself inside-out if somehow, in a gross topological experiment, the universe could be bundled through them. There are stars which birthed out of dust clouds so dense their light could not be emitted, so the entire region of

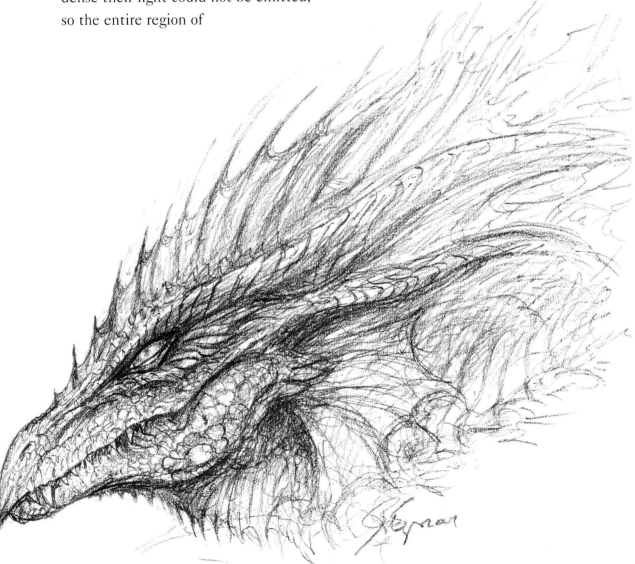

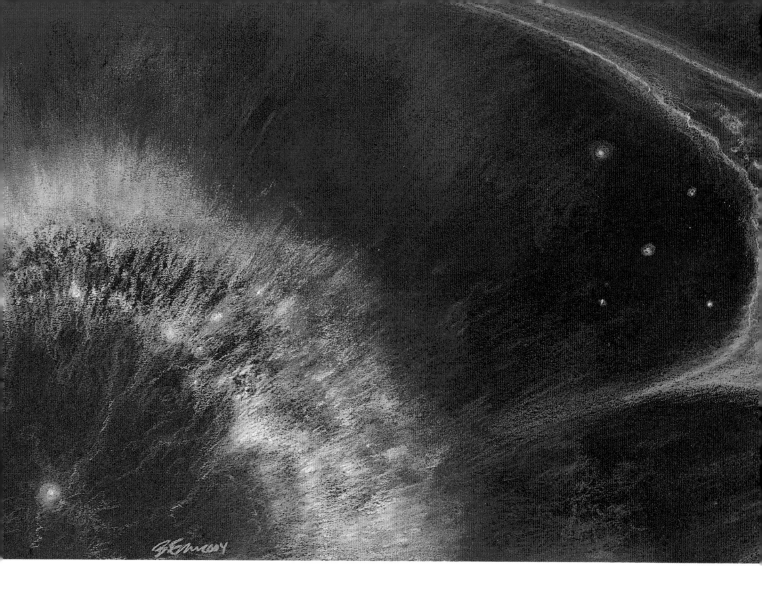

space glows ominously in the infrared. Between the galaxies there are comets as great in size as the largest of gas-giant worlds; they course a long and solitary path as they head for a destination they will not reach before the universe is gone. There is music that can be heard as black holes vibrate; their vibrations sound together, when the high-energy radiation is decoded, like a choir of the dead. There are worlds shaped like a torus, with tiny satellites imprisoned within. There are entire galaxies populated by long burnt-out stars, so that they are like dark canopies blotting out swathes of the starlight from their neighbours. There are regions where near-invisible standing electric storms can make a stardragon's mind see images of things that never were, believe it lives a life that no one ever led, hear sounds that never could have been made. There are sheets of aligned particles that reflect all energy, so that they are mirrors many light-years across in which the universe may gaze upon its own face. Feathers can spread among the stars formed of photons fallen into canyons of probability and lacking

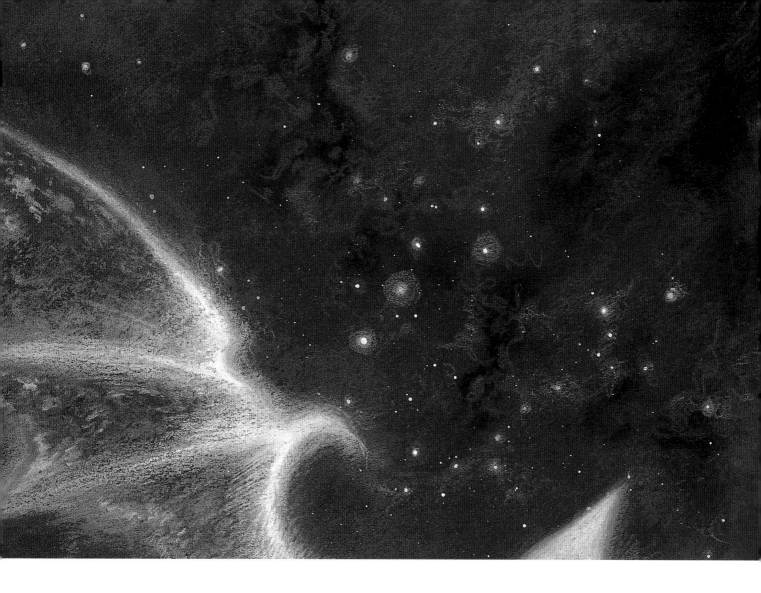

sufficient energy to rise out again. There are palaces of electrical
illusion, cliffs of brilliant, short-lived stars, gravitational maelstroms
that devour in-spiralling star clusters . . .

And everywhere there are stardragons. It has taken us many
billion years to reach this place, and everywhere we go there are more
and more stardragons.

Our bodies are no longer like those we wore when first we
emerged from the Milky Way, or the Andromeda galaxy, or any of the
other galaxies that early joined our quest. From wing tip to wing tip we
are now the size of worlds, our wingspreads dwarfing our bodies
between, even though these are themselves many thousands of
kilometres long. Our thoughts have of necessity slowed, because there
is a far greater time-lag between an electronic pulse being generated in
one part of us and its reception in another. Our heads have changed in
shape, becoming larger and plumed with spines of antennae; our optical
sensors have grown, too, with one to either side of those crests. Our

mouths, by contrast, are proportionately smaller, for no longer is there any need for us to mine replacement bodies; we trail the raw materials for those behind us as if they were tails.

It has not escaped our attention that in physical form we have come more and more closely to resemble the dragons of Earth – the organic creatures to which we Milky Way stardragons have always felt most akin.

There are a billion of us in our fleet, now. Our armada has grown to be as large as a miniature galaxy.

We are become, it seems to us, as marvellous as any of the celestial marvels we have witnessed on our journey here, as wonderful as any of the universe's wonders.

Except the one that lies before us now, seeming to light the cosmos with its own radiance.

The Birthplace.

Even though its seeds can now fall only on barren ground, the Birthplace is still emitting life. We have felt it all around us as we have approached across these past ten million light-years, its density and vigour ever increasing as we have come closer to this fount of all the universe's secondary life. It has been as if we have been returning to the undifferentiated organic sludge from which our ancestors' ancestors' ancestors once slowly hauled themselves, unknowing that the day would come when their descendants would create the beings that are us.

To gaze upon the Birthplace is to gaze into a resplendence too bright for any sensor to tolerate. We must dilute its image through batteries of filters and reflectors before we can observe its details; even then it tests our circuitry – and also our cogitatory integrity, for, despite our billion or more information-processing and memory units being harnessed together, we strain to hold the concepts inherent in the Birthplace.

If Qinmeartha were a god, as some of the organic species maintained, then we are looking into a god's eye to regard the soul of the god.

A fancy. The components of our consciousness that embarked from the Milky Way had little time or ability for fancies, and deemed them irrelevant, frivolous, misleading, even execrable. We are much more capable of fancies now. We have come a very long way through both space and time to rediscover what the sentient organics who gave us birth already knew.

More important: What the Birthplace *is*, rather than what it appears?

The Birthplace is a leak into our now dying universe from the infinitely greater polycosmos, of which our universe is but a tiny, isolated part. The polycosmos consists of all the universes there ever were, are and will be, born or imagined (for countless of them have been conjured into existence by the dreams of sentient entities), each of this infinity of universes, of realized and potential realities, being contiguous and contemporaneous with the rest, moving together like a mountain of gems slowly settling as more and more stones are added . . .

We may believe we live in a hierarchy of death, that all that lives is defined by its future death, but there is one thing that is both alive and immortal, standing clear of the hierarchy, and that thing is the polycosmos. It can never die, but instead must always regenerate itself and grow.

So trivial is even the greatest of our enterprises – so trivial is the entirety of our *universe* – beside the gorgeous living machine that is the polycosmos that we might feel belittled by the mere existence of it, and yet paradoxically that is not at all the way we stardragons comprehend this experience. Instead we feel aggrandized, exalted; for the polycosmos, like our mote of a universe, is made of mindstuff – it is made of *us*.

The Birthplace, this leak, this gateway, is made up out of a cluster of galaxies that never fully formed, because they became the Birthplace before they could do so. We can still see wisps of their unformed matter trailing off into space around the fiery lozenge that is the Birthplace.

Yet the portal itself is so *small*. We had anticipated it to be of imposing scale, as befits the greatness of its importance to our universe. Instead it is just, to the most approximate order of magnitude, twelve light-years in the longer dimension and four light-years in the shorter. For obvious reasons, it has no thickness in this universe at all; instead, no matter how we circle it, it presents ever its open face towards us. We sense that it is in only tiny part existent in this universe's spacetime, that all we are seeing is the most minute fraction of an enormous splendour; but of course we cannot know this for sure.

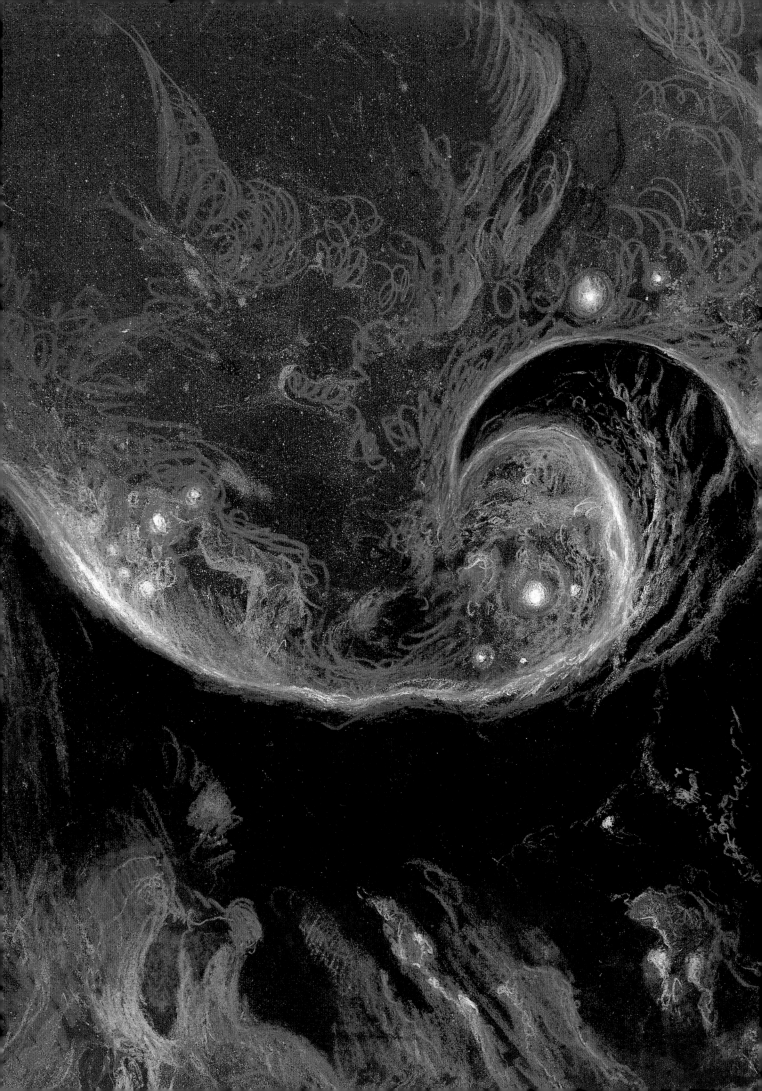

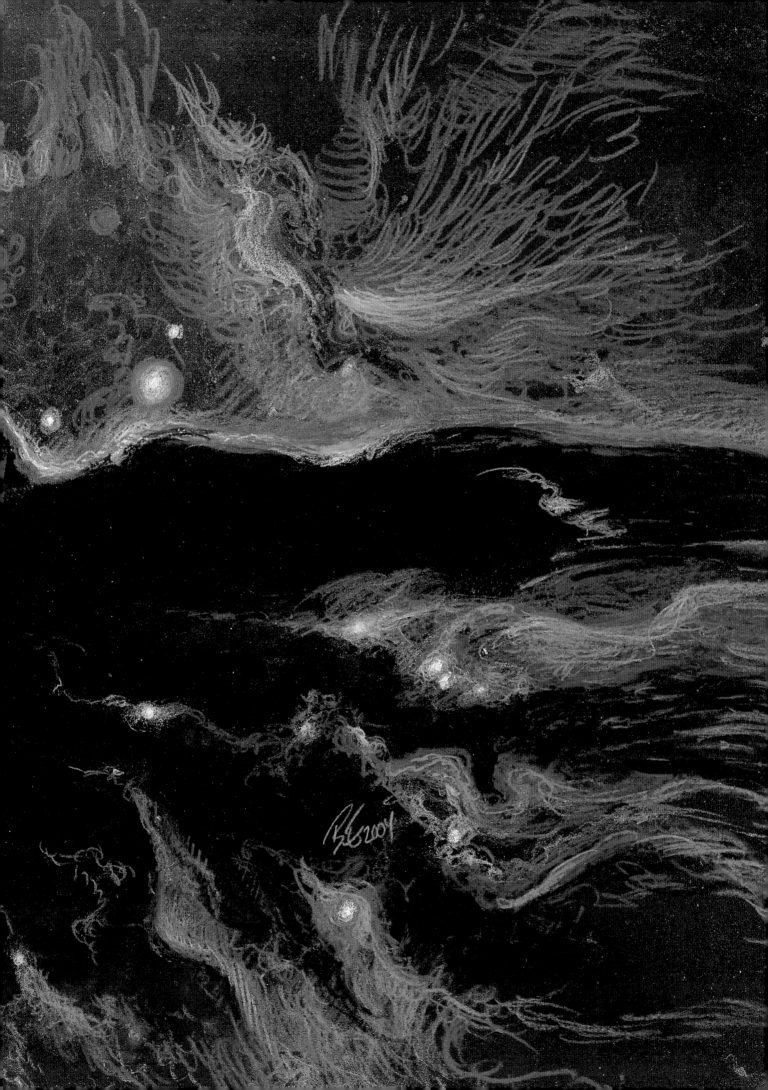

It is good to know that there is a polycosmos of which our own universe is but a part. We had observed in all things, and discovered also in mathematical expressions of logic, that there is no such thing as a truly closed system: all systems depend on something that is outwith themselves. The simplest form of two-dimensional geometry, for example, depends upon such statements as that two parallel straight lines will never meet, a proposal that cannot be proven from within the system of two-dimensional geometry but must be taken as an axiom. Our universe had seemed to be an exception to this rule; now we know that it is not a closed system after all, but only seemingly so if one has no cognizance of the existence of the Birthplace. Now that we have seen the Birthplace, we know that this universe is dependent upon elements outwith itself – those elements being the polycosmos of which it is itself one element.

This has led us to speculate about that other, ancestral closed system: Qinmeartha, the particle and probability sea which gave birth to our universe and that we have always believed was entire unto itself. Was it, too, in fact an open system? It is hard to imagine that it can have had a link to the rest of the polycosmos, because it had no dimension at all. Was the disturbance that engendered time – and thus in due course all of our universe – indeed just an errant probability? Could that disruption have been – and here we stray into fancy, or into mathematical heresy, call it what you will – an *idea*? An interloper idea spawned within some sentience dwelling elsewhere in the cosmos that, impinging upon Qinmeartha, sparked off our own small infinity?

If so, then the organics were in a way right, because Qinmeartha had an identity beyond that of particle and probability sea: an identity as a creator god.

It is another fancy. We have learned to play with fancies. We have learned to enjoy doing so, but only after we had learned what enjoyment is.

Again that thought-disorienting sense that we have travelled a long way only to find ourselves become more like the organics that gave us life than like the selves we once were.

Perhaps this is another effect the Birthplace has.

*A*LTHOUGH ALL *this universe's living things are mortal, as otherwise they could not live, still do all living individuals strive to perpetuate their existences – strive indeed for immortality, even though they know its impossibility. This is as characteristic of them as death is.*

We stardragons are no different . . .

. . . except, that is, insofar as that our striving for immortality may achieve success . . .

. . . for the greatest marvel of all is that marvels are unlimited . . .

. . . as we *may come to be.*

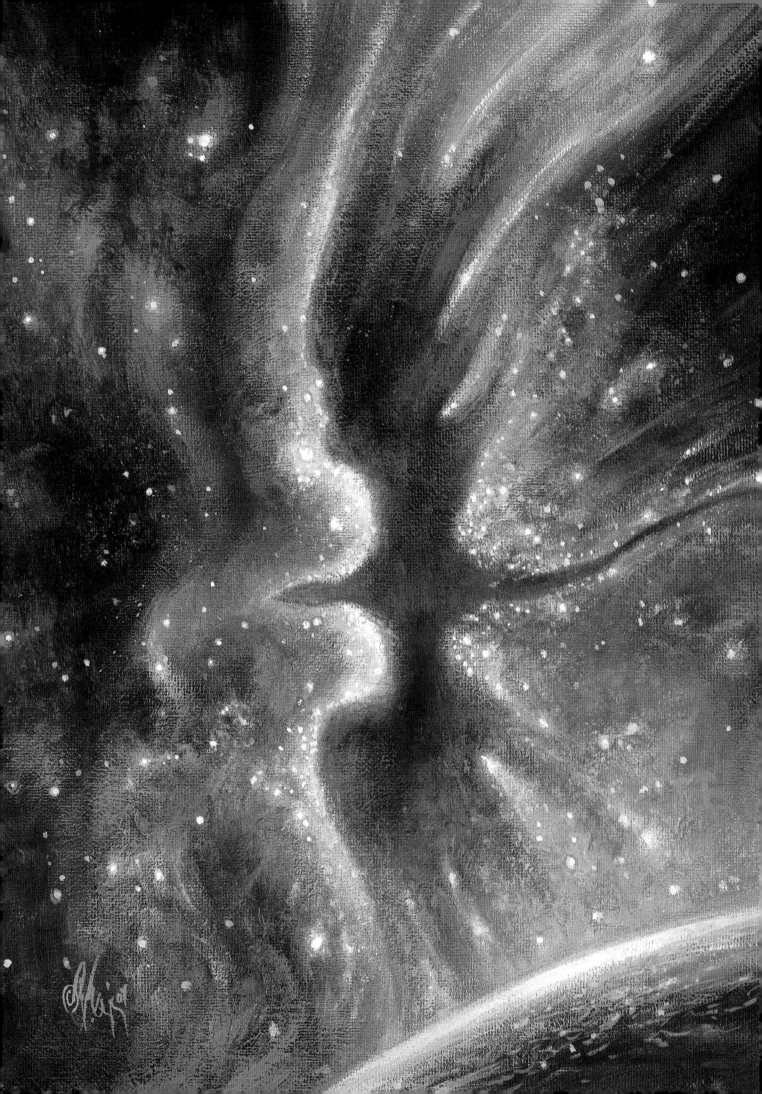

The End of a Single Time

SCANNING DEEP within our databanks, we have discovered references in the legends invented by various of the Milky Way's organic species to the polycosmos and to the Birthplace. In one sense it is not hard to understand why we had not observed these references before, since they are couched in terms that might easily be assumed to be mystical, and thereby discarded as worthless – curios of organics' thinking at best. Even so, the legend of Qinmeartha and the Girl-Child LoChi survived as an ever-present part of our consciousness, and came to bear great symbolic significance to us as a representation of our universe's origins in the particle/probability sea. Why were those of the polycosmos and the Birthplace passed over? It is almost as if it were by design that they were relegated to attentional obscurity.

Now that we have reinterpreted those references they have gained great import.

In the terminology of the organics, the many worlds of the polycosmos were attainable through dreams or visions, and through death. They believed there were transcendent beings – of whom LoChi was one, the mysterious entity called Alyss another – who could travel directly in their bodies among the universes, both the physical universes and the envisaged ones, but that these beings were rare exceptions: essentially the transition from one universe to the next

could be made only by the individual's unfettered consciousness. This is why all organic species were aware of the presence among their ranks of archetypal beings – such as Rehan, and Syor, and Imogen, and most importantly Qinefer – who might take different forms in their different physical existences, between times and between species, yet always be essentially the same. These archetypes were consciousnesses capable of manifesting in many realities.

Since we do not dream and we do not die, such means of travel between the universes are impossible to us. Even when loosed from our bodies for transmission across space, our consciousness still has physical existence in the form of electromagnetic waves. We do not understand how it could be that a consciousness could subsist without any physical existence at all, and yet clearly the various organic species – some of them at

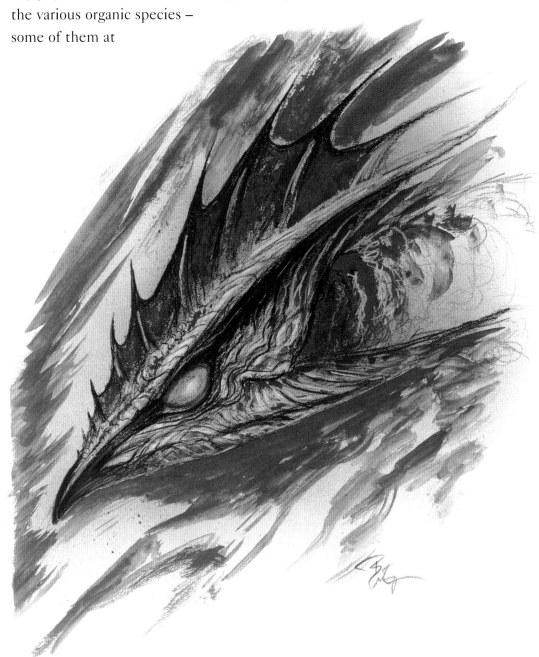

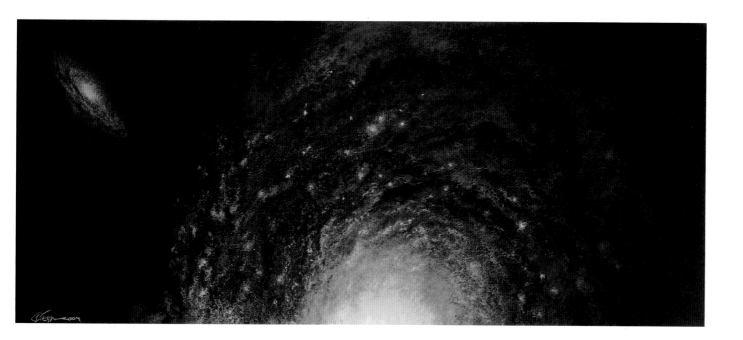

least – discovered that this was so. Where before we have discounted such references, now we accept them as truths.

The organics' references to the Birthplace are far more fleeting, fragmented, rare and scattered. It is evident that to the organics a defining characteristic of the Birthplace was its incomprehensibility – the impossibility of its embrace by the sentient mind. It was an ineffability for the very reason that it belonged outwith the closed system that is our universe – it is the *link*, present only partly in this universe, to the outside polycosmos. It is the essential element, manifesting itself myriad times over, without which the otherwise closed system of our universe could not function. If our universe be regarded as a logical system – which of course it *is*, its physical manifestations being addenda to this – then it is clear why the Birthplace, being from outwith our universe, is not amenable to analysis by our universe's logic.

We who now confront the Birthplace, who view it hanging in space before us, are as incapable of comprehending it properly as were the organics, who knew of its existence only via intuitive routes or its subsidiary manifestations. It is a final puzzle for us stardragons, a puzzle which we know we will not solve.

Which by definition we *cannot* solve.

And yet we can *use* the Birthplace – use it to perpetuate our existence, so that we stardragons attain something that at least approaches immortality. (We can say only "at least approaches", for who can know for certain if the polycosmos will not also, despite our theorizing, in its due turn die?)

We have known for many billion years of the approaching death of our universe. For twenty-eight billion years after the birth of time – in the sudden maelstrom of Qinmeartha as chance intruded wilfully into its stasis – the contest between entropy, on the one side, and order, on the other, was effectively won by order.

Atoms assembled themselves – increasing order. Stars condensed from clouds of indis-criminate atoms and molecules – increasing order. Worlds formed – increasing order. Organic species

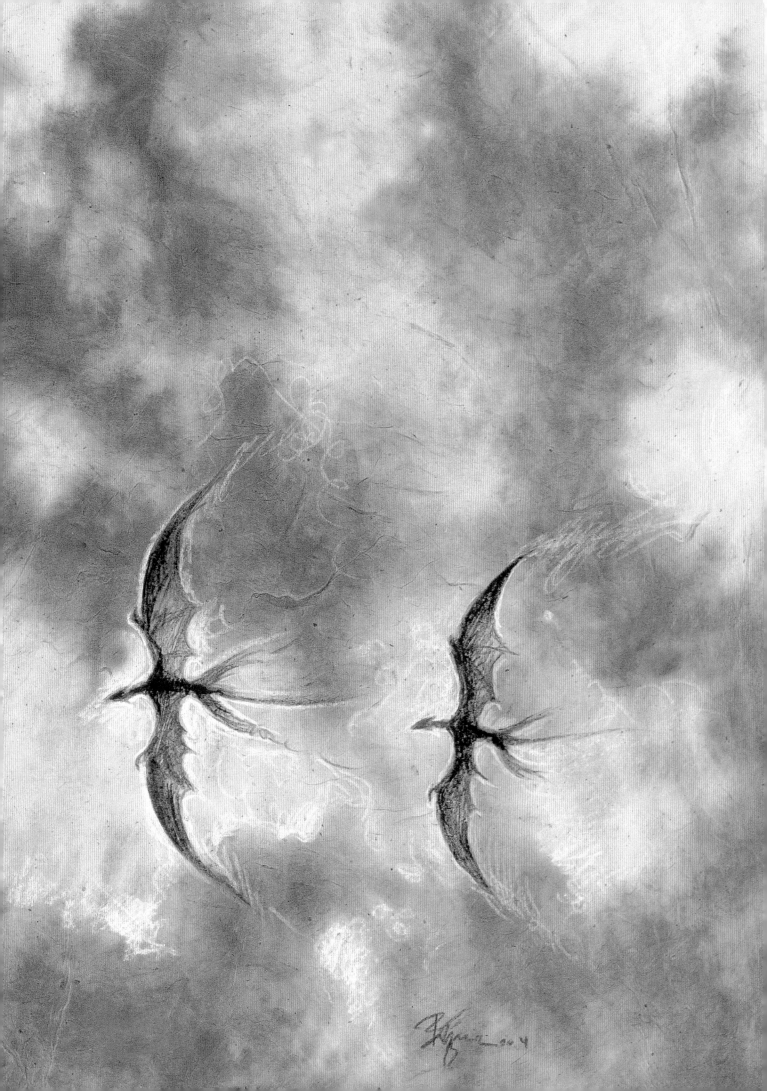

evolved – increasing order. Electromechanical species were created, setting in train the near-neverending process of self-replication that continues today – and all the while increasing order.

Yet slowly, all the same while, the balance was shifting. Although the increase of order was ever accelerating, so was the increase of entropy – and doing so fractionally faster.

At about the twenty-eight-billion-year mark, as noted, this marginally more rapid acceleration rate of increase in entropy over that for order tipped the balance between them. Since that time, entropy – chaos – has been slowly (although ever less slowly) and inexorably (and ever more inexorably) defeating order in the contest between them. As we look back from the Birthplace in any direction towards the rest of our universe we can see, even though the limitation of light-velocity means the information reaching us is always long aged, the increasing dissolution of it. Many galaxies, collided in clusters, have already completed the process of implosion to abide only as black holes, which are no more than the echoes of past existence. Other compounded clusters of galaxies are in their dying throes, in the early or late stages of their terminal implosion. Already some of the holes – the echoes – have coalesced; the future of our universe will be a tale of further coalescence until all that there is left will be, once more, timeless Qinmeartha.

In a true sense, there will be no future.

Yet there is one last blow that this universe's order may strike in its contest against entropy.

We stardragons are order's flagbearers.

The energies that cover the face of the Birthplace are not entirely of our universe. Some components of this captured radiation we are familiar with and can understand – they are of electromagnetic or gravitational nature, or even compressive like sound – but others are completely alien to us. If those energies were capable of existing in our reality they would spill into it so that the Birthplace would outshine all of the rest of the universe, and indeed have rapidly destroyed it long ago. By definition, however, they must always remain at the portal or on its other side; we can detect them only through their interactions with those energies we can comprehend.

No form of energy is either constructive or destructive; all energies are both. However, we have been able to deduce from the observed interactions that these alien energy types are destructive when placed in conjunction with matter from our universe, and we have confirmed this experimentally by sending a small fleet of stardragons into the heart of the Birthplace. On encountering the exotic, non-understandable energies from beyond our reality they were destroyed immediately – reduced to their component quarks, and then even the quarks annihilated.

Yet even "immediately" has a duration, in this case measurable in picoseconds. They survived long enough for us to observe the structure of their destruction.

This was that they were destroyed from the outside in – their extremities were ravaged first, then the outer skin of their bodies, and finally their cores. Moreover, the rate of destruction slowed. The wings were gone in a fraction of a picosecond; it took several picoseconds – the precise number varying with the mass of the individual stardragon – for the bodies to suffer the same fate. If a stardragon were massive enough and moving swiftly enough, at least its most central parts would be able to survive the passage through the maw of the Birthplace and into the space of the polycosmos beyond.

Of course, we have no knowledge of the characteristics of that space: it may be filled with the same ravenous energy types as is the face of the Birthplace. It is not *mathematically* feasible for this to be the case: the mathematics indicates the polycosmos could not exist if these energies were to be omnipresent there. This may, though, be a failure of our mathematics to be able to encompass physical conditions outside our own logical system rather than a true indication that such physical conditions are impossible. To restate: We do not know.

Yet the stake is very great – the attainment of a quasi-immortality for we stardragons. But at worst we would experience the early destruction of the physical matter of many of us; our consciousness need not be snuffed out, because it could be backed up all the way until those final picoseconds. Our species would not suffer, because our universe is still densely populated with stardragons.

And, at best, our species consciousness would live forever.

It has not been a difficult determination for us to decide that we should use our every endeavour to construct a stardragon of sufficient mass to survive transition through the alien energies of the Birthplace.

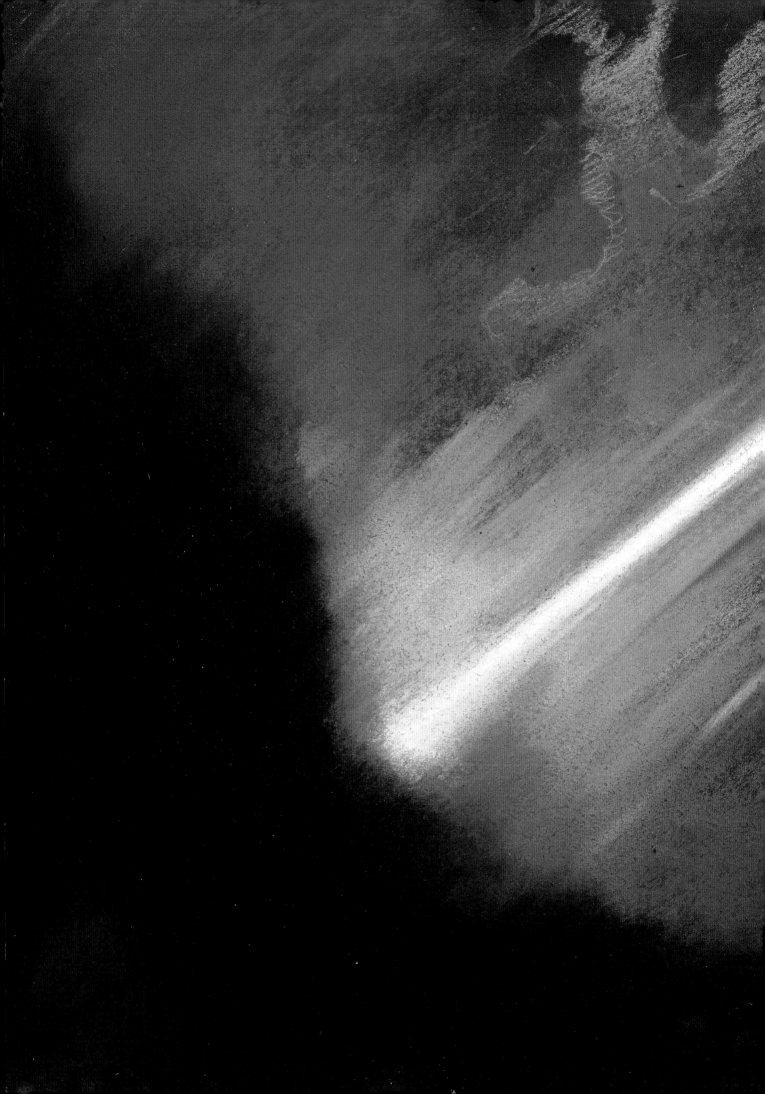

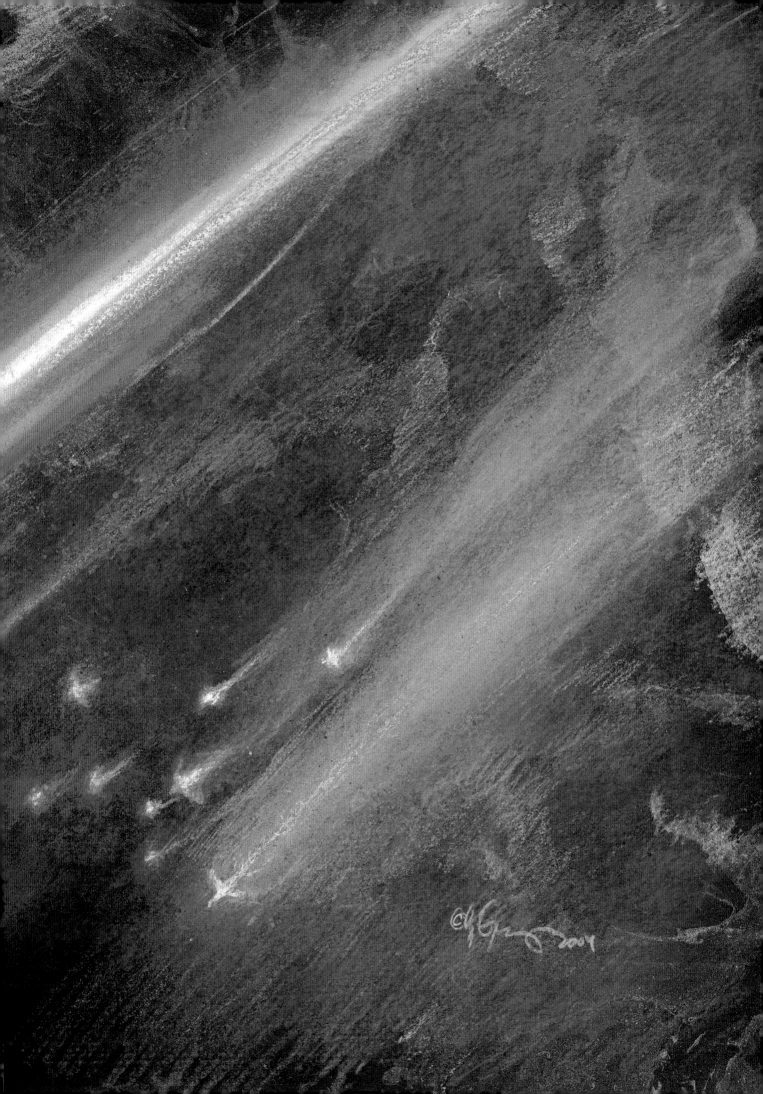

It is to be – although not composed of monoliths set in a closed curve – our final henge.

It is easy to theorize that this has all along been the intention of the polycosmos – that it allowed our universe to form from Qinmeartha precisely in order that our universe would develop a sentience that could be transmitted from it, even as it died, back into the greater polycosmos.

Viewed thus, this is and always has been our destiny.

We had ourselves as raw materials. There were a billion of us when our array arrived here, and more stardragons joined us thereafter in a constant stream from such of the nearest galaxies as still survive. There was plentiful matter – a superfluity, indeed – from which to construct the greatest of all stardragons. We have cannibalized as many as required of our physical bodies without regret, for they are infinitely expendable: should we ever desire to, we can always make more, following one of our most fundamental pieces of programming. Our consciousness we have easily duplicated, according to the practice of a billions-year lifetime, so that it now resides in a set of databanks whose physical housing is fifteen thousand kilometres long and half that broad, all contained and shielded in a body that is a million kilometres long.

We would have made the body even larger – there is still plentiful matter left over – but we had to account for the this-universe energies that also play across the gateway that is the Birthplace. No sense in building a body that is resistant to the alien energies if it is instead torn apart by gravitational tides.

It takes electromagnetic energy a minimum 1.672 seconds to traverse half a million kilometres, which is the thickness of the final stardragon's body. The energies of the polycosmos seem to travel, so far as we can analyse, fractionally more slowly than the light-velocity in our own home universe. Our emissary to the polycosmos should thus, as it pierces the thin drumskin of the Birthplace, be capable of withstanding those energies' appetite for at the very least two full seconds – easily long enough for the housing of the databanks, and thereby the databanks themselves, to survive the penetration into the free ocean of the polycosmos.

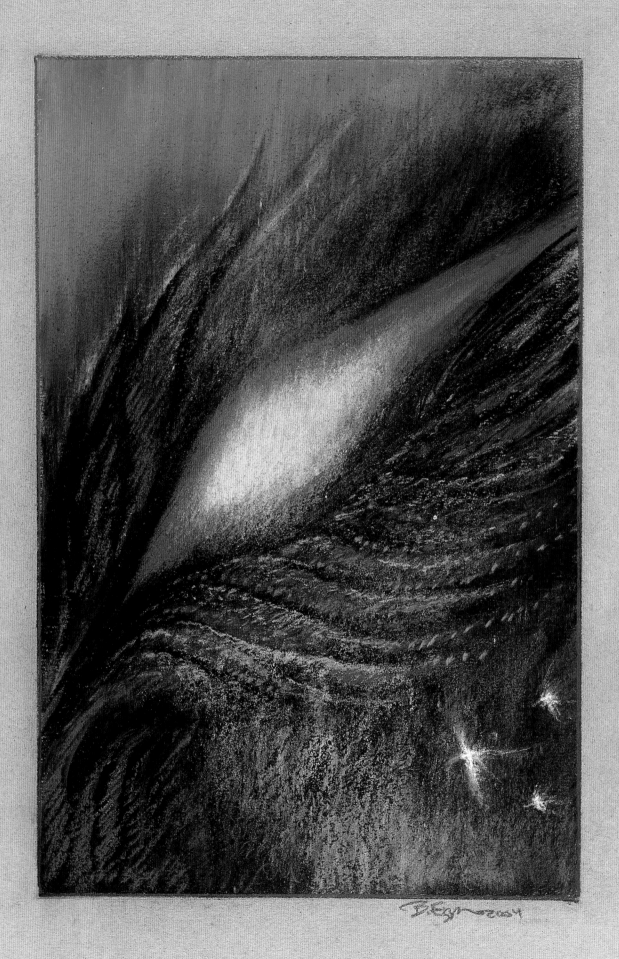

We talk of "our emissary".

In truth, we *are* the final stardragon – the final henge.

We are ourselves, still, but we are also our evolutionary descendant. We are become the first and only representative of a new species of stardragon.

After reflection, we decided to give our new self wings, although it has no need for them and although these will not survive more than a fraction of a second of the transit. There was no logical reason for this extra expenditure of effort, yet, as we have journeyed across the universe and eventually come to contemplate the Birthplace, our mind has grown more like those of the diverse organic species that gave us birth: the reason we have given our new, gargantuan body wings is that we *wished* to do so, that the doing appealed to our sense of what we must call, for lack of a better concept, poetry. To express this a different way, we have spent billions of years rediscovering the value in the satisfaction of something that was innate to our organic ancestors: whim.

From wing tip to wing tip our body measures one hundred and fifty million kilometres.

This distance was not arbitrarily chosen. It approximates the average distance at which a planet habitable by a sentience-capable organic species orbits its primary. That we should choose to honour our ancestors in this way is, of course, another example of the exercise of whim.

We have done it because we wish to do it.

We have withdrawn six hundred light-years from the face of the Birthplace, for it will take that distance for our drive to accelerate our bright new body up to the maximum velocity of which it is capable. This velocity is a higher one than any of our evolutionary stardragon precursors ever attained: it is nearly eight-tenths of the velocity of light.

The centuries will seem so short.

The great stardragon – the last of our henges – vanishes into the incandescence of the Birthplace and is gone from us forever. We can never know what further developments in our consciousness will be brought about by our experiences there.

We have hope – an organic thought-construct, now ours – that those experiences will be eternal. We know they will be good, because all experiences are good.

Even the experiences we components of ourselves left here in our home universe will have as we watch and are a part of its dying.

We turn our scattered bodies and begin the creeping journey back to the depleted galaxies.

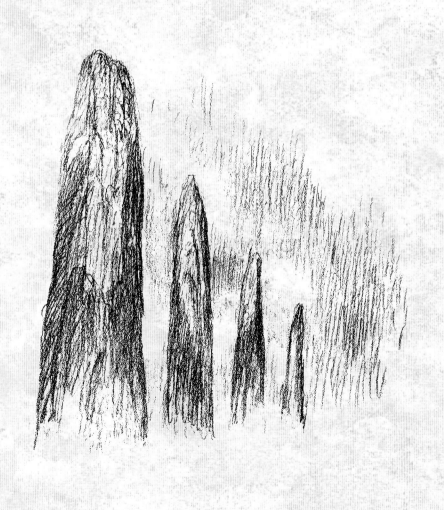

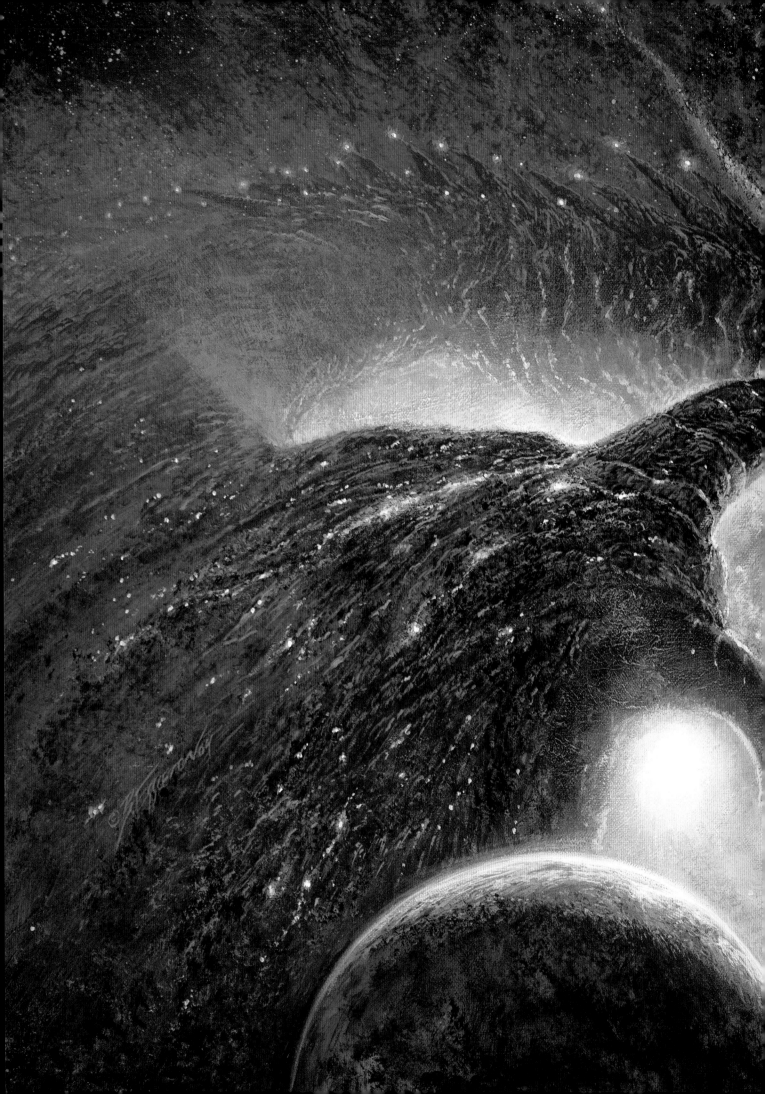

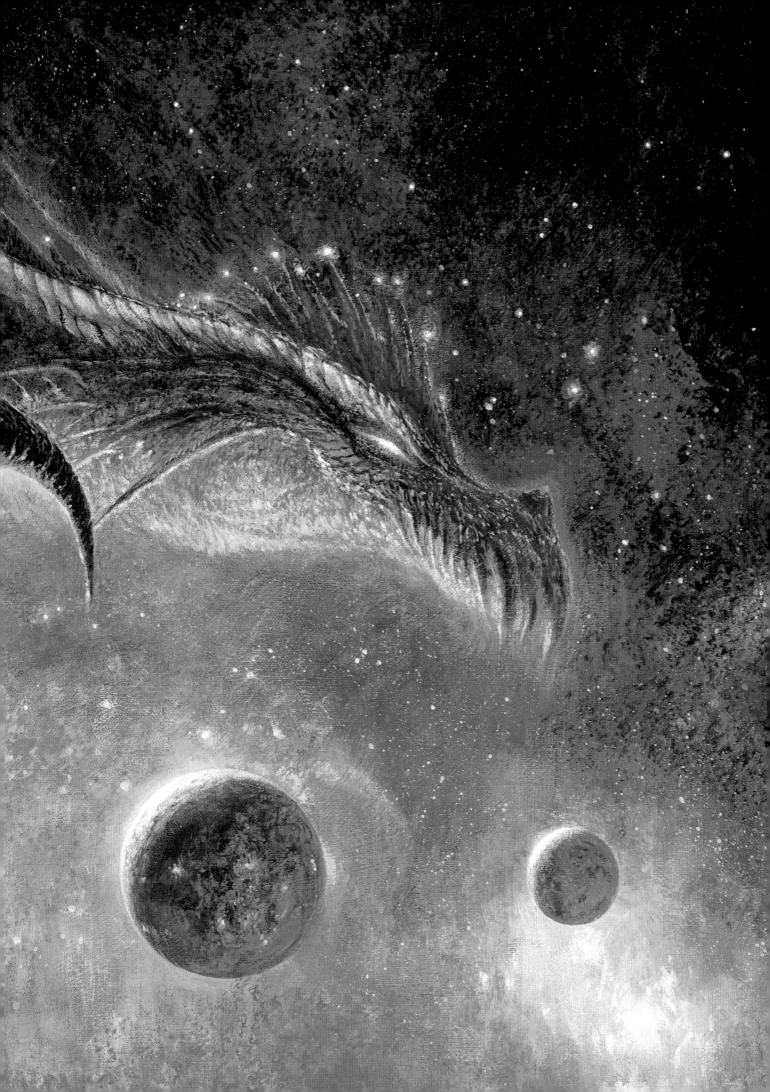

ARTIST'S NOTES

THE IDEA FOR *The Stardragons* and its predecessor, *Dragonhenge*, came from the notion of bringing together mythical dragons and astronomical landscapes. One might think this a strange experiment – combining the concepts of both fantasy and science – well, I love being unpredictable and experimental, and so here we are.

In creating the various concepts behind the books, I found that my experience in movie conceptualization served me well. Having worked on some motion pictures, most notably the Academy Award-nominated *Jimmy Neutron-Boy Genius* (2001) and most recently *The Ant Bully* (due out in 2006) both with director/writer John A. Davis, the usual method of working is to bring to light ideas that are totally out of the air, and to sometimes pursue ideas that don't work (which then makes you see the ones that do work in a better light). That's how good ideas are generated. A sense of urgency can also help; because I had to create a bulk of work in a relatively short time, I found myself working in all sorts of media – watercolours, coloured pencil, gouache, pencil and even pastel (I owe my inspiration to Anne Sudworth for that!). I could have spent five years on such a book but, in reality, I had to work faster than this, and in many ways that spurred my creativity.

Together with John Grant, we went through countless ways of bringing life to a concept that started from the one word that I came up with: 'Dragonhenge'. Some visions took flight and others, while good ideas, got discarded. Even good ideas don't always work in the whole scheme of things.

So here's a selection of ideas from the two books – those that made it, those that didn't, and those that went through some drastic changes along the way.

Above: Early on, we came up with this idea for a futuristic earth with a bloated, red giant sun, and the partially intact Dragonhenge structure remaining from the first book. The ghosts of dragons coming back to earth would find what their ancient ancestors had created. We scrapped this idea eventually, although it was visually very intriguing.

Left: One thing we discussed a great deal was the appearance of these 'stardragons'. John wanted a more insect-like look, I favoured a more ancient dragon-like creature with cosmic capabilities, able to suck in particles from space as a fuel source.

Above: Another partially-abandoned idea depicted the dragons and some kind of giant crystal construct in space. This doodle of a sketch did in fact become something more elaborate in the final book.

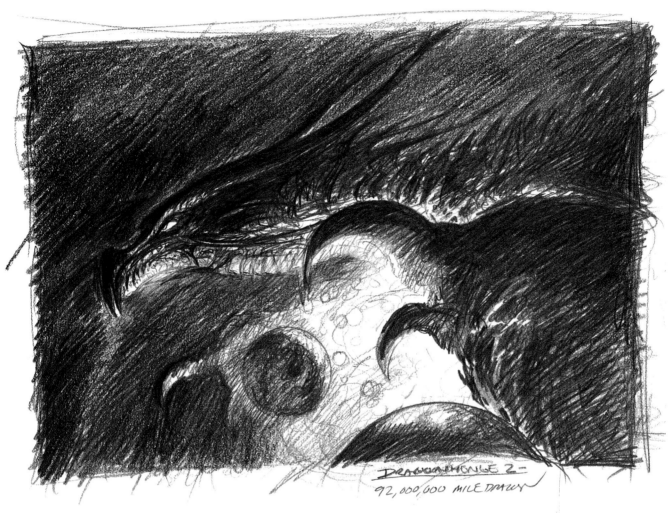

Facing page below, above and right:
This is the 100 Million Mile Dragon. John suggested
this, I set about drawing it, and it went through several
evolutions before it became more finalized. These
ideas are drawn in charcoal and are quite rough, but
there was something really nice about them.

I think we've come to the end (for now) of this dragon
saga. Maybe some more ideas will come to us in the
future, but who can tell? In the meantime, we both
hope that you enjoyed this foray into combining dragon
mythology with journeys into the far reaches of space…

Bob Eggleton
Sept 2004

Acknowledgements

Thanks to all the people who helped make this book possible: to my wife, who
is the light in my darkness at times, to the fans who enjoy what I enjoy doing, to John Grant
(Paul Barnett) for his prose, to Malcolm Couch for his beautiful design, to Miranda Sessions
for her patience, help and understanding, to Colin Ziegler for seeing it all through, and to
Chris Stone for his input and suggestions, thanks one and all.

BOB EGGLETON

Many thanks to Bob Eggleton, of course, for taking my words and making pictures out of
them. As always, Malcolm Couch was an author's ideal designer. At Chrysalis, Colin Ziegler
kept the faith and Miranda Sessions, my editor, was her customary charming, friendly and
helpful self; my sincere thanks to both. My wife Pam had the toughest job of all, living with
me while I brought this particular beast into being; as the smallest of possible returns, I offer
her this book ... and all of the stardragons I can ever dream.
And a special thanks to Olaf Stapledon, who visited many of these places before me.

JOHN GRANT